rhubarb

50 TRIED & TRUE RECIPES

Corrine Kozlak
photography by Kevin Scott Ramos

Adventure Publications
Cambridge, Minnesota

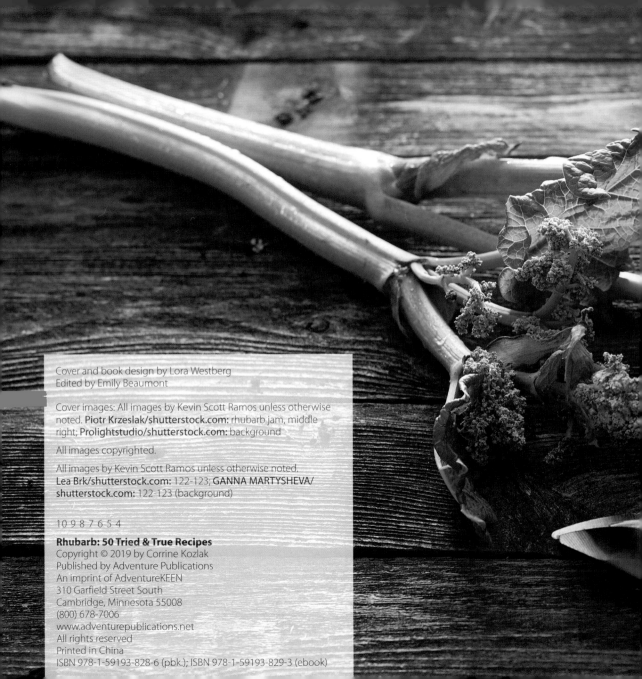

Cover and book design by Lora Westberg
Edited by Emily Beaumont

Cover images: All images by Kevin Scott Ramos unless otherwise
noted. **Piotr Krzeslak/shutterstock.com:** rhubarb jam, middle
right; **Prolightstudio/shutterstock.com:** background

10 9 8 7 6 5 4

Rhubarb: 50 Tried & True Recipes
Copyright © 2019 by Corrine Kozlak
Published by Adventure Publications
An imprint of AdventureKEEN
310 Garfield Street South
Cambridge, Minnesota 55008
(800) 678-7006
www.adventurepublications.net
ISBN 978-1-59193-828-6 (pbk.); ISBN 978-1-59193-829-3 (ebook)

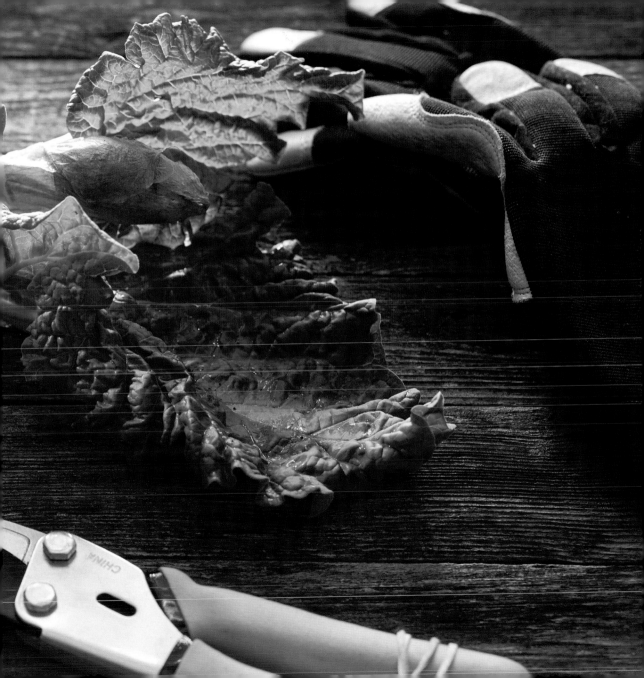

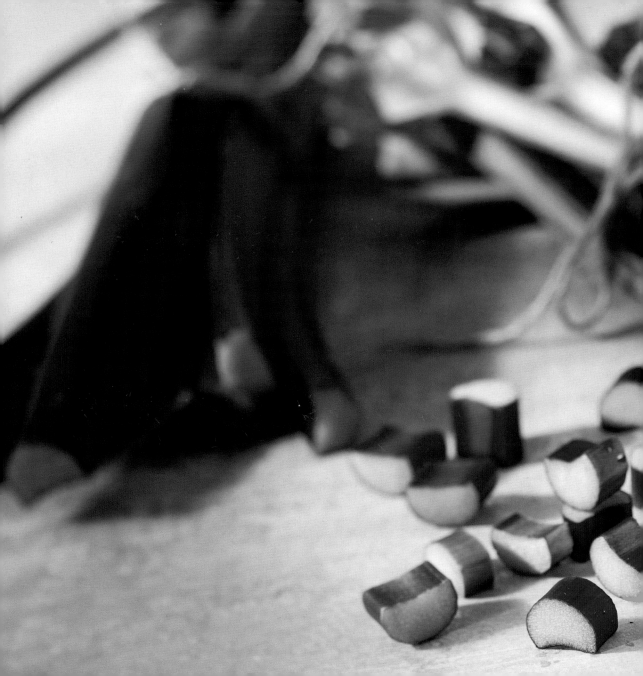

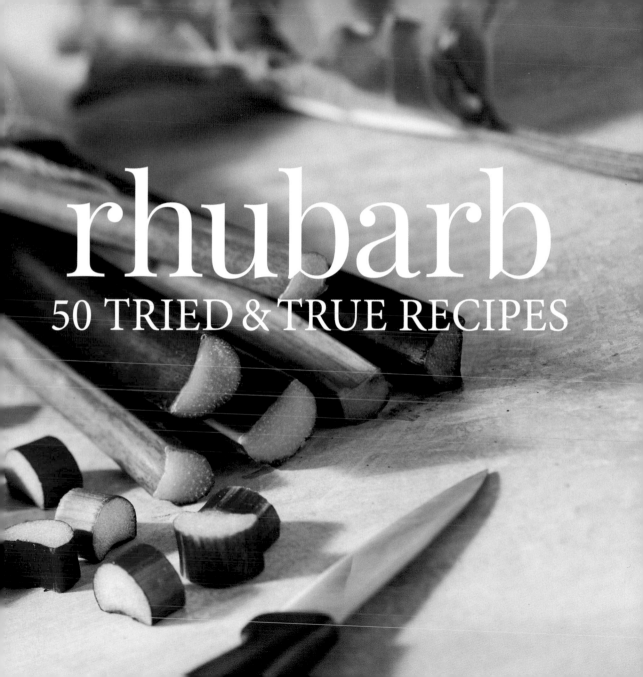

rhubarb
50 TRIED & TRUE RECIPES

Acknowledgments

I would like to express my gratitude to all who contributed and helped me create this cookbook, especially the following.

- The photographer Kevin Ramos, who gave freely of his time and talent—way beyond his compensation

- My family: Dan, Danny, and Callie Kozlak, for tasting recipes and helping me with my computer and writing questions, and Erin, my daughter-in-law, who inspired the gluten-free additions

- My mom and dad, for all their help, from gathering handwritten and newspaper-clipped recipes to helping me find a new home for my rhubarb plants

- Dear friends of my family Margie and Art, who deserve a special callout

- Donna Hawkins, whose recipes and cookbooks were so helpful

- My cousin Julie, who not only supported my rhubarb efforts but who also sheltered me for 8 months. I also want to thank Julie's rhubarb-loving neighbors: Mary Spangler, who gave me oodles of handwritten recipes that were inspirations for many of the recipes in this book, and John Heitke, for his generosity in letting me pick as much rhubarb as I wanted from his patch.

- "My girls" and especially Vicki, for her recipes and all the lovingly cleaned and picked Minnesota spring rhubarb

- Frank and Tina Ziegler, without whose support, love, and professional advice I would not have gotten this project going

And a great many thanks to all of my family and friends, who were very supportive during this project.

rhubarb

50 TRIED & TRUE RECIPES

Table of Contents

Acknowledgments 6

Plant, Eat, Love . 10

Rhubarb History 12

Growing Rhubarb 14

Tips for Cooking with Rhubarb. 16

Tips for Making a Lattice Crust. 18

Best Basic Rhubarb Recipes 20

Straight-up Perfect Rhubarb Pie 23

Simple Rhubarb Sauce *GF 25

Rhubarb Crisp . 27

Rhubarb Custard Cake to Take 29

Rhubarb for Breakfast 30

Overnight Oatmeal Cake
 with Rhubarb Sauce 33

Rhubarb-Bran Breakfast Muffins 35

Rhubarb Scones 37

Rhubarb Coffee Cake 39

Rhubarb Streusel Bread 41

Rhubarb Parfait 43

Rhubarb-Blueberry Breakfast Sauce *GF . . 45

Pies . 46

Best Double Piecrust 49

Grandma's Rhubarb Custard Pie 51

Strawberry-Rhubarb Pie 53

Rhubarb Streusel Pie. 55

Fourth of July Blubarb Pie 57

Rhubarb Galette 59

Peach-Rhubarb Pie 61

Rhubarb Hand-Pie Pops 63

Rhubarb Tarte Tatin. 65

Mini Strawberry-Rhubarb Tarts 67

Desserts: Cakes, Cookies, Bars 68

Rhubarb Cobbler 71

Pavlova with Rhubarb,
 Strawberries, and Fresh Cream *GF 73

Rhubarb Cupcakes with
 Strawberry Frosting. 75

Rhubarb-Strawberry Shortcake 77

Rhubarb Upside-down Cake 79

Rhubarb Cheesecake. 81

Rhubarb Jam Pinwheel Cookies 83

Rhubarb Oatmeal Cookie Bars. 85

Rhubarb Dream Bars 87

Savory: Mains, Sides, Sauces. 88

Rhubarb Salsa . 91

Rhubarb Party Salad 93

RB&O Sauce. 95

Rhubarb Ketchup 97

Rhubarb Meat Pie . 99

Pork Tenderloin with
 Rhubarb Sauce. 101

Frozen Treats. **102**

Rhubarb Ice Cream. 105

Strawberry-Rhubarb Milkshake. 107

Rhubarb Ice Pops. 109

Rhubarb Fool . 111

Jams & Jellies **112**

Rhubarb Jam. 115

Rhubarb-Onion Chutney 117

Rhubarb Hot Pepper Jelly 119

Small-Batch Strawberry-
 Rhubarb Jam . 121

Beverages. **122**

Rhubarb Simple Syrup 124

Rhubarb Slush Punch. 125

Rhubarb Bellinis . 126

Rhubarb Daiquiris . 127

Rhubarb in the City. 128

Rhubarb Pie Cocktails. 129

Index . **130**

About the Author & Photographer **136**

*GF denotes gluten-free recipes.

Plant, Eat, Love

A common perennial, rhubarb is one of the first springtime plants to emerge from under the winter garden debris. Rhubarb has a tart, earthy, subtle but distinctive flavor. Rhubarb often conjures up memories of mothers, grandparents, favorite aunts, and neighbors. My first memory of rhubarb is going out into my grandparents' urban garden and simply dipping the freshly picked, ruby-red stalks into a bowl of sugar and eating them raw. People love rhubarb because it connects them to a time and to a plant that is predictable and dependable.

A Culinary Newcomer

Native to Asia and now found around the world, rhubarb has been grown for medicinal purposes for centuries. Nonetheless, as a food, rhubarb is a relative newcomer; the first rhubarb crops grown as a food date back to the 1600s. The first recipes calling for rhubarb are even more recent, dating back to the early nineteenth century.

Rhubarb's Toxic Leaves

There's an obvious explanation why rhubarb didn't catch on quickly as a food: its leaves are somewhat toxic, perhaps leading would-be connoisseurs to think that rhubarb's stalks were dangerous as well. Rhubarb leaves contain oxalic acid. When large amounts of oxalic acid are ingested, it can lead to kidney failure and death. But that would take some real effort; a lethal dose requires ingesting around 11 pounds of sour, unpalatable rhubarb leaves.

Rhubarb Nutrition

Rhubarb stalks contain far less oxalic acid (similar to the amounts found in spinach) and are safe to consume. Nutritionally, rhubarb consists of 95 percent water; ⅔ cup raw rhubarb has only 17 calories. It is a good source of potassium, vitamin C, dietary fiber, and calcium.

The Recipes in This Book

The recipes for this book have been carefully developed or selected and adapted. The best basic recipes were chosen because they represent what people really like to make with rhubarb. These basics have become a spring ritual for many rhubarb lovers. I chose recipes that I like to make, that are not too sweet but still contain a nice balanced rhubarb flavor.

I have also included ways to use rhubarb for breakfast and in recipes for jams and beverages, but, of course, it is the desserts that make us love the humble but delicious rhubarb plant the most. I invite you to make these recipes and really taste the rhubarb with your eyes as well as with your palate.

How to Cook with This Book

Be sure to read through the ingredients list before beginning a recipe. This will give you the best sense of how much time is needed to prepare a dish. Some ingredients may require preparation or equipment (e.g., a juicer) of their own.

And it's helpful to have all of your items ready to go before you begin. The French call this *mise en place* (everything in its place).

Also, while we call for using our Best Double Piecrust (page 49) in our pie recipes, feel free to substitute store-bought refrigerated piecrust dough when you're short on time.

Rhubarb History

Long known as a medicinal plant, rhubarb has a fascinating history. Rhubarb is native to China, where it has been used as a purgative for thousands of years. This quality made the plant a popular commodity, and it was traded widely among the Greeks and Romans, and later, on the famous Silk Road.

Rhubarb was also touted for its reputed ability to ameliorate fevers and stomach pain; it was even used in attempts to help prevent the plague. Prior to the rise of modern medicine, purging one's system was a common method to treat various ailments; as a mild laxative, rhubarb root was a perfect fit, and its prices boomed, at times exceeding those of famously expensive goods such as cinnamon and saffron.

"Strange Rhubarb"

Known botanically as *Rheum rhabarbarum*, rhubarb's species name *rhabarbarum* is a combination of two Greek words. The first, Rha, is a former name for the Volga River, which flows through Russia and much of Europe. As this was an area where cultivated rhubarb was grown, *Rha* was also the Greek word for the plant. The other part of its species name stems from the Greek word *barbaros*, the root for our word "barbarian." The Greeks originally used it to mean "strange" or "foreign," and this usage was later picked up by the Romans, who used it to refer to any non-Roman/Greek civilization. Thus, Rhubarb's species name literally means "strange rhubarb."

Rhubarb Gains Popularity

The first use of rhubarb in a culinary setting appeared in an early recipe for tarts and pies. Once sugar became more widespread and accessible, rhubarb's popularity boomed, especially in England. Rhubarb was introduced to the United States in 1770—by Benjamin Franklin no less—and by the middle part of the nineteenth century, it was being cultivated, becoming popular first in New England and later, elsewhere, including in the Upper Midwest.

Rhubarb Spreads Across North America

Rhubarb soon was planted (and transplanted) across the country, becoming a seasonal tradition wherever it could grow. Before World War II, rhubarb was very popular. With the war came the

rationing of sugar; and because rhubarb was hardy and easy to grow—and wasting anything was essentially viewed as counter to the war effort—U.S. families were somewhat forced to use and eat unsweetened, sour rhubarb. This combination of factors made a war-weary nation grow tired of the plant. After the war, sugar became widely available again, and new tropical fruits and vegetables were introduced, making rhubarb seem old-fashioned.

Rhubarb Today

Lately, rhubarb has been enjoying a resurgence. The plant is now in vogue again, and it is showing up in the news, in cookbooks, and in magazines. With the present emphasis on locally grown foods, and with upscale chefs always looking for new flavors to incorporate into their dishes, rhubarb is now being served with fish, meat, and in a variety of other creative and interesting ways. Rhubarb is not just the "pie plant" any longer.

Growing Rhubarb

Technically speaking, rhubarb is a vegetable, but because of its close association with sweets, especially pies, it's often informally considered a fruit. Rhubarb is one of the few perennial vegetables that exists, and it requires cold weather to survive.

Planting Rhubarb

Rhubarb, once established, is a very easy and hardy plant. It is normally sold in garden centers as *one-year crowns*. Rhubarb likes well-drained soil with lots of organic matter. When planting, place the root about an inch or two below the surface; then fill in the soil around the plant, and pack it down lightly. Top with garden compost or other well-rotted organic material. If you already have an established plant, you can split up an established root, but only if it's at least five years old. To do so, dig up the root and split it into three or four pieces, and make sure that each portion has pink growing buds. I recommend growing rhubarb in full sun, but it is fairly tolerant of partial shade. Once planted, rhubarb does not like to be disturbed.

Important: If your rhubarb plant starts to develop seed pods (this is called bolting), cut them off as soon as you can. If they are allowed to flower and go to seed, the plant will not devote as much energy to creating fleshy stalks and you won't have as much rhubarb to harvest.

Harvesting Rhubarb

During a plant's first season, don't pick any stalks. During the second season, pull only two to three stalks per plant, leaving at least five healthy ones. During later seasons, pull three to five stalks at a time, making sure you leave three to four on the plant. In a given year, you should be able to harvest three to five times, starting as early as April and as late as August. Harvest stalks by gently pulling and twisting them as low as possible to the base of the plant. Cut most of the green leaves off of the collected stalks, leaving just a small amount of leaves to protect the stalks from drying out. If you are not going to use it right away, wrap rhubarb tightly in plastic wrap and store it in the refrigerator. Remove the leaves before using the rhubarb.

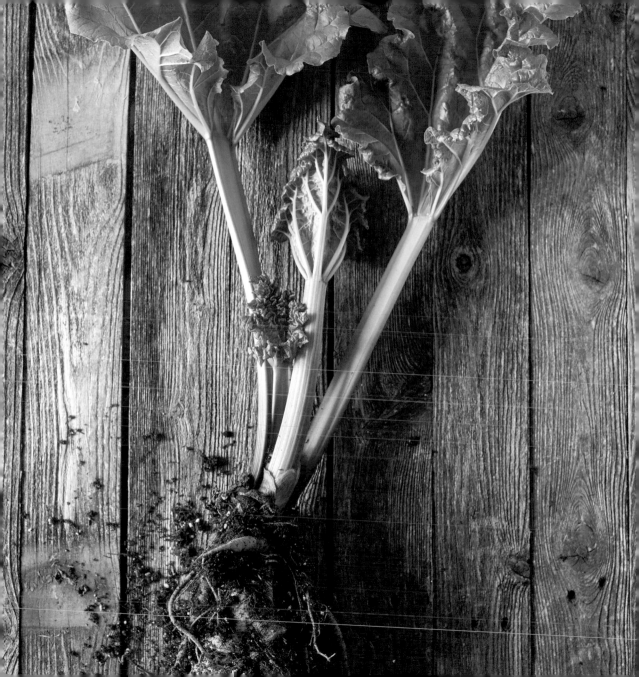

Tips for Cooking with Rhubarb

When you cook with an ingredient for many years, you learn about its quirks, which equipment works best, and so on. Rhubarb is no different: here are some of tips and tricks I've learned while cooking with it.

Measuring rhubarb: 1 pound rhubarb is equal to about 8 medium-size stalks, 3 ½ cups diced, or 2 cups cooked.

Cooking rhubarb: It cooks down quite quickly over medium heat with a few stirs and a little liquid. Be careful not to oversweeten it.

Freezing rhubarb: It's the best way to extend the season. Wash, cut, and place in freezer bags. To better preserve the color, blanch washed and cut rhubarb by plunging it into boiling water for 1 minute, then into an ice bath for 1 minute; drain well and spread in a single layer on a sheet pan. Freeze for at least 2 hours and then put into freezer bags.

Thawing frozen rhubarb: Place it in a colander positioned over a bowl to catch the rhubarb juice. The juice can be used for beverages and for a flavor boost in other recipes.

Choosing a food processor: I like the Cuisinart food processor, and I have had the same one for 30 years. I find it is the best tool for making pie dough and emulsifying dressings.

Choosing cookware: Use nonreactive pans, such as anodized aluminum, stainless steel, Teflon-coated aluminum, and enamel-coated cast iron cookware. Rhubarb cooked in reactive metal pots (aluminum, iron, and copper) will turn an unappetizing brown color.

Choosing pie plates: I like metal pie plates better than glass or foil ones because I have found that bottom piecrusts crisp up better in metal pie plates.

Using tapioca: Some of the recipes call for tapioca, so make sure you buy the instant kind (quick-cooking or Minute Tapioca) so that no uncooked tapioca balls show up in your baked goods.

Making fluted edges: After you have rolled the dough out to a circle that is about 2 inches beyond the rim of the plate, fold the dough over in fourths and gently transfer it to the pie plate, pressing gently into the bottom of the plate. (Cut dough if it is uneven.) Fold the dough under the edge of the pie plate for a nice fat edge. Then, using two fingers from one hand (on the outside of the plate) and one finger from the other (on the inside of the plate), push the dough with one finger between the other two fingers; continue around the pie.

Using an egg wash: Crack one egg in a small bowl and whisk in about 1 tablespoon water; before baking, brush egg mixture on the piecrust and sprinkle with sugar.

Lining a pan with aluminum foil: This trick is from my food-styling days, and it allows you to lift your baked goods out of the pan and get more accurate and accessible cutting. Turn the pan over to conform the foil to the back side of the pan; then carefully remove and place formed foil on the inside of the pan. Proceed as instructed.

Creaming sugar and butter: This means to mix on high speed until the mixture is fluffy and a light yellow color. Use softened butter for best results.

Tips for Making a Lattice Crust

Rhubarb pies are delicious, no matter what crust you use. But to really show off your creation, try making a pie with a lattice top. Often seen in culinary magazines, the intricate end result is actually fairly easy to produce. Here's what you need to know.

Roll out 1 disk chilled piecrust dough into two (11-inch circles), about ¼-inch thick. Cut one of the dough circles into strips about ¾-inch wide. Cover and refrigerate dough if you still need to prepare the pie filling.

Line a 9-inch pie plate with the uncut dough circle; fill with pie filling.

Starting with the longest strips, lay the first two strips in an X in the center of the pie. Alternate horizontal and vertical strips. Weave them in an over-and-under pattern, using the shortest strips for the edges of the lattice.

Press the ends of the strips firmly to the rim of the pie. Trim away any excess dough.

Whisk together 1 egg and 1 tablespoon cold water in a small bowl. Brush piecrust dough with egg mixture, and sprinkle with sugar.

Bake as directed in the recipe, shielding with aluminum foil, if necessary, to prevent excessive browning.

This type of crust is suggested for Straight-up Perfect Rhubarb Pie (page 23) and Peach-Rhubarb Pie (page 61).

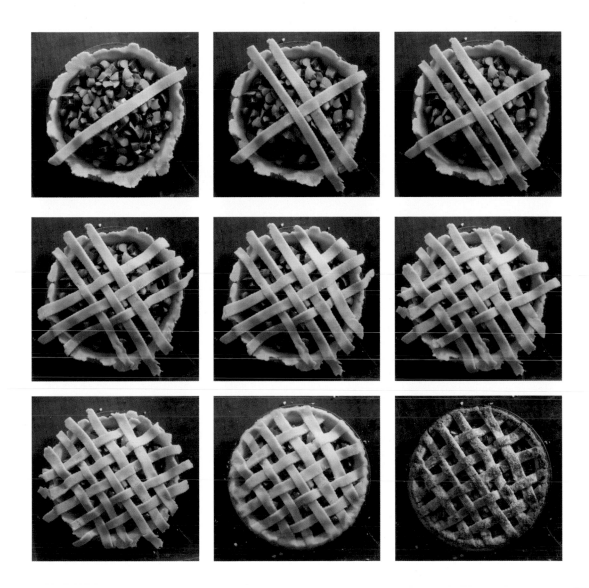

best basic rhubarb recipes

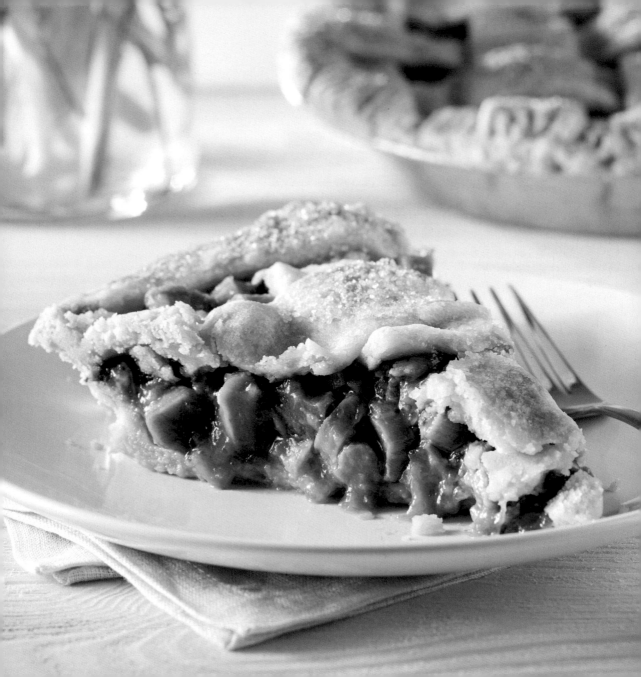

Straight-up Perfect Rhubarb Pie

This delicious pie is a beautiful combination of several recipes. Everyone I serve this to says,
"It's the best rhubarb pie ever!" This recipe calls for our Best Double Piecrust (page 49),
which you'll want to prepare ahead of time, unless you're substituting a store-bought refrigerated piecrust.

makes 8 servings

INGREDIENTS

1 cup granulated sugar, divided
2 tablespoons instant tapioca
¼ teaspoon orange zest
¼ teaspoon cinnamon
5 cups chopped rhubarb
 (about 10–12 medium-size
 stalks, cut into ½-inch pieces)
1 egg
2 teaspoons cold water
1 tablespoon all-purpose flour
1 Best Double Piecrust
 (page 49)
1 tablespoon milk or cream
2 tablespoons raw or large-
 crystal sugar
Vanilla ice cream

In a large bowl, combine ¾ cup granulated sugar, tapioca, orange zest, and cinnamon; add chopped rhubarb, and toss to coat. Whisk together egg and 2 teaspoons cold water in a small bowl; stir into rhubarb mixture. In a separate small bowl, combine remaining ¼ cup granulated sugar and flour.

Preheat oven to 425 degrees.

Roll out 1 disk chilled piecrust dough into an 11-inch circle. Line a 9-inch pie plate with dough, and trim edges; sprinkle bottom crust evenly with sugar-flour mixture. Top with rhubarb mixture.

Roll remaining dough disk into a circle, and cut into ½- to ¾-inch-wide strips. Create a lattice top over rhubarb mixture, crimping edges as desired (see page 18). Brush top crust with milk and sprinkle with raw or large-crystal sugar.

Place pie on a rimmed baking sheet, and bake for 15 minutes. Reduce oven temperature to 350 degrees, and bake for 20 minutes or until crust is golden brown and filling is bubbling. Cool slightly. Serve warm or cold with vanilla ice cream.

Simple Rhubarb Sauce *GF

This tastes especially good over vanilla ice cream, but it can also be used over pound cake, on Greek yogurt with granola, or blended with frozen fruit and yogurt in a smoothie.

makes ½ cup

INGREDIENTS
1½ cups chopped rhubarb
(about 4 medium-size stalks,
cut into ½-inch pieces)
3 tablespoons sugar
1 tablespoon water or
orange juice

Stir together rhubarb, sugar, and water in a medium-size saucepan over medium-high heat until sugar dissolves. Simmer, uncovered, 5–10 minutes, stirring often, until mixture is tender and slightly thickened (applesauce consistency). Cool, and place in an airtight container; refrigerate up to 5 days.

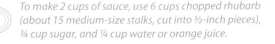

To make 2 cups of sauce, use 6 cups chopped rhubarb (about 15 medium-size stalks, cut into ½-inch pieces), ¾ cup sugar, and ¼ cup water or orange juice.

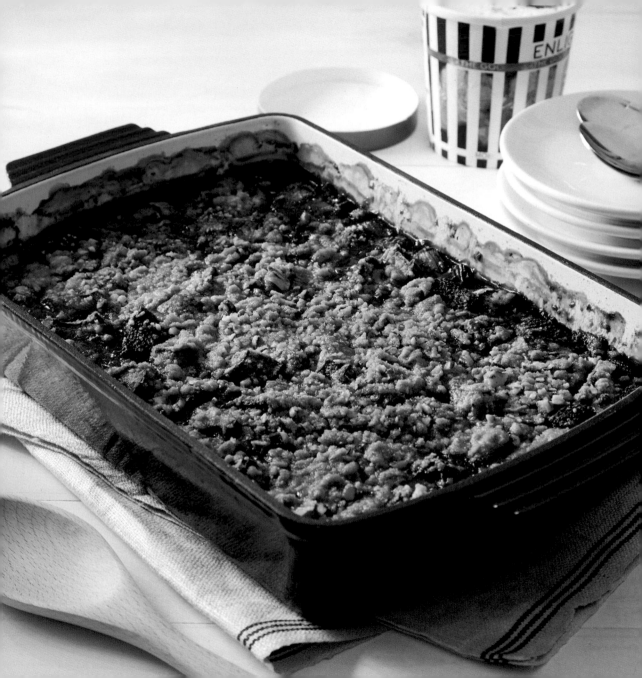

Rhubarb Crisp

This recipe was adapted from one that appeared in the *Chicago Tribune* in 2003 by the late, great Abby Mandel.

makes 8 (1-cup) servings

FILLING

6 cups chopped rhubarb (about 12–15 medium-size stalks, cut into ½-inch pieces)
5 cups (2½ pints) strawberries, hulled and halved
1¼ cups sugar
3 tablespoons plus 1 teaspoon instant tapioca
3 tablespoons fresh orange juice
1 tablespoon finely grated orange zest
2 teaspoons vanilla extract
½ teaspoon allspice or pie spice

TOPPING

1 cup all-purpose flour
⅔ cup dark brown sugar
1 teaspoon cinnamon
⅛ teaspoon salt
8 tablespoons unsalted butter, softened and cut into 4 pieces
¾ cup pecans

Preheat oven to 350 degrees.

To make filling, combine rhubarb, strawberries, sugar, tapioca, juice, zest, vanilla, and allspice in a large bowl. Transfer fruit mixture to a 9x13-inch nonreactive baking dish or 8 (1-cup) ramekins.

To make topping, place flour, brown sugar, cinnamon, and salt in the bowl of a food processor with a metal blade; pulse twice to combine. Add butter and pecans, and pulse until mixture crumbles, about 20–30 seconds. Sprinkle topping mixture evenly over filling in baking dish or ramekins.

Bake 1 hour (30 minutes for ramekins) or until top is lightly browned and juices bubble.

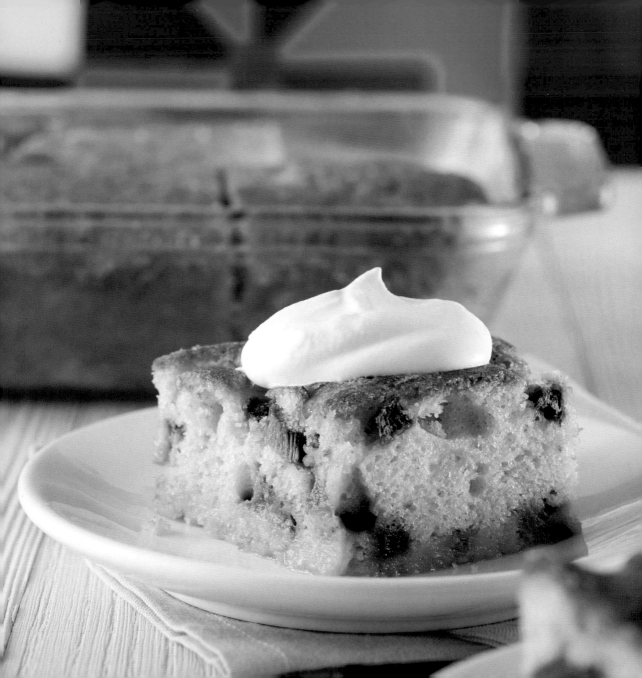

Rhubarb Custard Cake to Take

• •

I tested this recipe with four different cake mixes and liked Pillsbury Moist Supreme Yellow Premium Cake Mix the best. (Add water, oil, and eggs as directed.) This delicious and popular cake tastes even better—and cuts nicely—if refrigerated overnight. Expect a few cracks on top and a moist, custard-like bottom, as some of the rhubarb sinks while baking.

• •

makes 1 (9x13) cake

INGREDIENTS
1 (15.25-ounce) premium
 yellow cake mix
4–6 cups chopped rhubarb
 (about 8–15 medium-size
 stalks, cut into ½-inch pieces)
¾ cup sugar
1 cup whipping cream
Sweetened whipped cream or
 vanilla ice cream

Preheat oven to 350 degrees.

Lightly grease a 9x13-inch baking pan. Prepare yellow cake batter according to package directions. Pour batter into prepared pan.

Spread rhubarb evenly over batter. Sprinkle sugar over rhubarb, and pour whipping cream over everything.

Bake 1 hour. Remove cake from oven; cool, cover, and refrigerate overnight. Serve with sweetened whipped cream or vanilla ice cream.

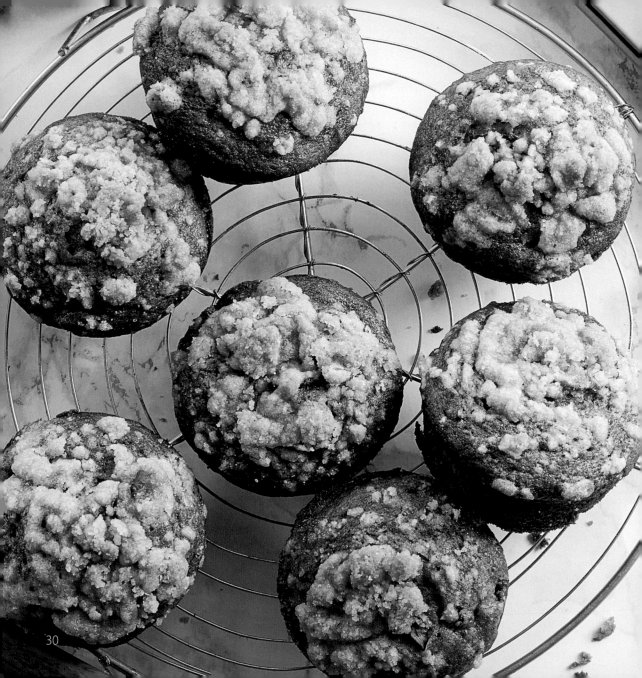

rhubarb for breakfast

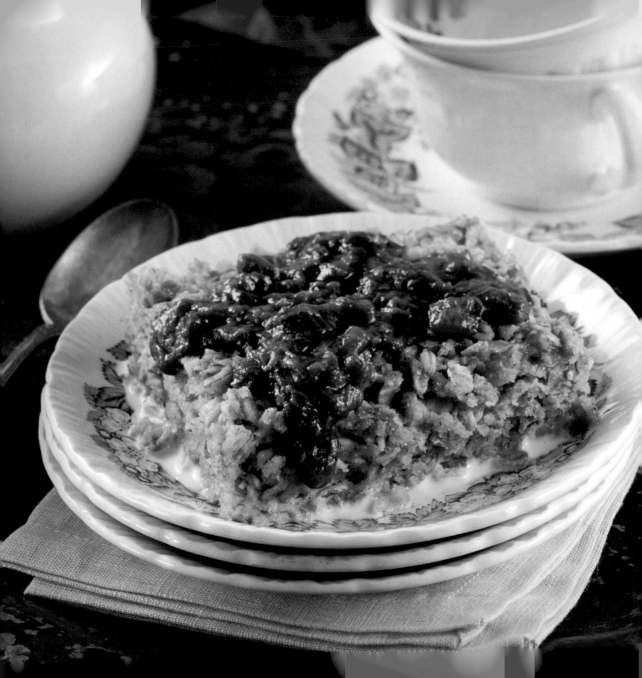

Overnight Oatmeal Cake with Rhubarb Sauce

You can let them eat cake for breakfast with this delicious, healthy oatmeal treat—a great way to get a non-oatmeal eater on the right side of oats. Make the Rhubarb Sauce ahead, and refrigerate overnight; reheat before serving.

makes 6–8 servings

INGREDIENTS

3 cups old-fashioned oats
2 cups whole milk
⅓ cup light brown sugar
¼ cup butter, melted
2 large eggs
1½ teaspoons salt
1 teaspoon vanilla extract
½ teaspoon cinnamon
Whipping cream
Rhubarb Sauce (see right)

Combine oats and milk in a large mixing bowl. Cover and refrigerate overnight.

Preheat oven to 350 degrees.

Stir brown sugar, butter, eggs, salt, vanilla, and cinnamon into oats mixture until well blended.

Pour batter into a lightly greased 8x8-inch baking dish. Bake for 30 minutes. Cool slightly, and cut into squares. Serve each square in a shallow bowl with warm whipping cream and Rhubarb Sauce.

Rhubarb Sauce: Cook **4 cups chopped rhubarb** (about 8–10 medium-size stalks, cut into ½-inch pieces), **½ cup water,** and **½ cup granulated sugar** in a medium-size saucepan over medium heat until soft, about 20 minutes. Remove fruit mixture from heat and purée if needed. Chill overnight, if desired; serve warm. Makes 2 cups.

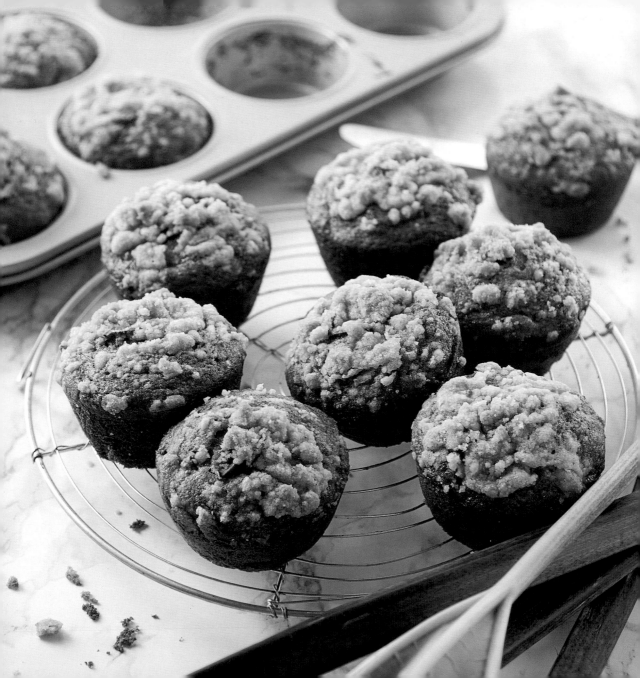

Rhubarb–Bran Breakfast Muffins

• •

This throwback bran muffin recipe was very popular in the 1970s, at the
dawn of healthy eating, and will bring back some good memories.

• •

makes 12 muffins

STREUSEL

¼ cup all-purpose flour
¼ cup light brown sugar
⅛ teaspoon salt
2 tablespoons cold
 unsalted butter

BATTER

1 cup All-Bran dry cereal
1 cup buttermilk
1 egg, beaten
½ cup corn oil
1½ cups all-purpose flour
¾ cup light brown sugar
1 teaspoon baking soda
½ teaspoon salt
1½ cups chopped rhubarb
 (about 4 medium-size stalks,
 cut into ½-inch pieces)
12 slices rhubarb

To make streusel, stir together flour, brown sugar, and salt
in a medium-size bowl. Using fingers, work butter into flour
mixture until medium-size clumps form; chill.

To make batter, combine cereal with buttermilk in a large
bowl until cereal is soft (about 20 minutes). Stir in beaten
egg and oil.

Preheat oven to 400 degrees.

In a separate bowl, mix flour, brown sugar, baking soda,
and salt. Add flour mixture to cereal mixture, stirring just
to combine. Fold in chopped rhubarb.

Place 12 muffin cup liners in muffin pan, or grease muffin
pan with cooking spray. Spoon batter into prepared cups,
filling ¾ full. Sprinkle each with streusel, and top with a
rhubarb slice. Bake 20–25 minutes.

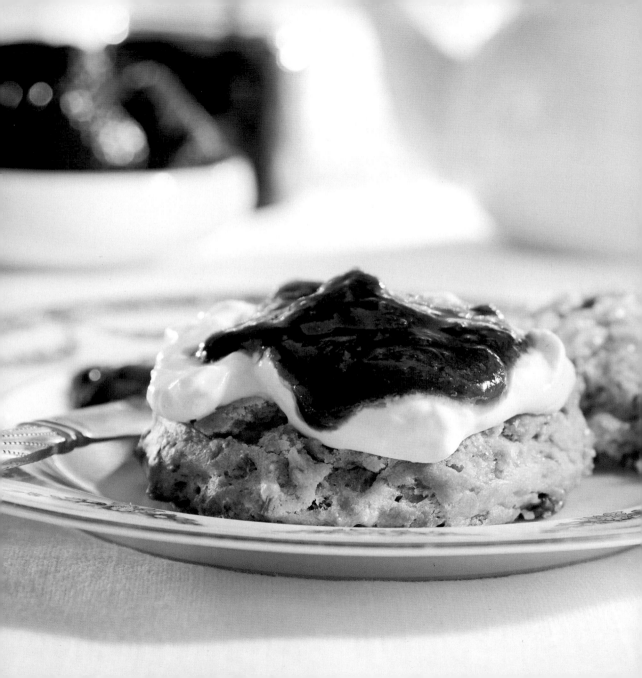

Rhubarb Scones

• •

Enjoy these scones alongside a spot of Earl Grey or Rose Congou hot tea. Delicious classics are classics for a reason. To be proper, serve scones warm. Place enough cream and jam onto your plate for each half. Using your hands, break your scone into two pieces. Using a knife or spoon, spread first with cream, then jam. Please do not create a sandwich. Eat and repeat.

• •

makes 16 scones

INGREDIENTS

1 cup chopped rhubarb
 (about 2–3 medium-size
 stalks, cut into ¼-inch pieces)
⅓ cup granulated sugar, divided
2¾ cups all-purpose flour
1 tablespoon baking powder
1 teaspoon baking soda
½ teaspoon salt
8 tablespoons unsalted butter,
 cubed and frozen
1 cup buttermilk
Raw or large-crystal sugar
Americanized Devonshire Cream
 (see right)
Small-Batch Strawberry-Rhubarb
 Jam (page 121)

Preheat oven to 375 degrees.

Combine rhubarb with 1 tablespoon sugar in a small bowl.

Place remaining sugar, flour, baking powder, soda, and salt in the bowl of a food processor with a metal blade; pulse twice to combine. Scatter butter over flour mixture, and process until mixture resembles coarse meal. Slowly add buttermilk, and process just until a soft dough forms. Place dough on a lightly floured surface. Sprinkle rhubarb mixture on top.

Using an ice-cream scoop, spoon 16 (¼-cup-size) dough rounds onto a parchment paper-lined baking sheet, about 1 inch apart. Sprinkle lightly with raw or large-crystal sugar. Bake for 25 minutes. Serve warm with Americanized Devonshire Cream and Small-Batch Strawberry-Rhubarb Jam.

Americanized Devonshire Cream: Combine **1 cup whipped cream cheese spread, 1 cup sour cream**, and **¼ cup granulated sugar** in a medium-size bowl. Whisk together until creamy and thick. Makes 2 cups.

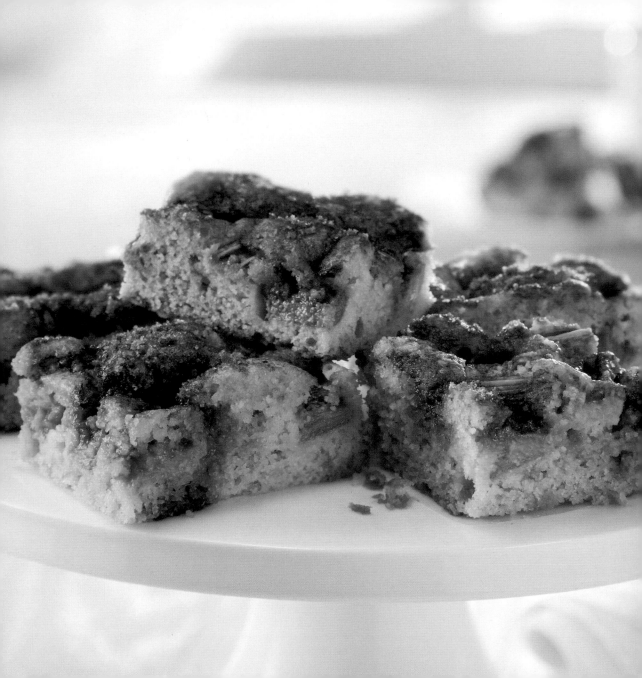

Rhubarb Coffee Cake

This popular and delicious recipe was given to me by Pam Fitzell.

makes 12 servings

BATTER
8 tablespoons butter, softened
¾ cup light brown sugar
¾ cup granulated sugar
1 teaspoon vanilla extract
1 large egg
1 teaspoon baking soda
1 tablespoon hot water
2 cups all-purpose flour
1 cup buttermilk
2 cups chopped rhubarb (about
 3–5 medium-size stalks, cut
 into ½-inch pieces)

TOPPING
¾ cup light brown sugar
1 teaspoon cinnamon

Preheat oven to 350 degrees. Grease and flour a 9x13-inch baking dish using butter.

To make batter, cream butter and sugars in the bowl of a stand-up electric mixer; beat in vanilla and egg. Combine baking soda and 1 tablespoon hot water in a small bowl; add to butter mixture. Beat in flour, ½ cup at a time, alternating with buttermilk. Fold in rhubarb, and pour batter into prepared baking dish.

To make topping, combine brown sugar and cinnamon; sprinkle on top of batter. Bake for 35–40 minutes.

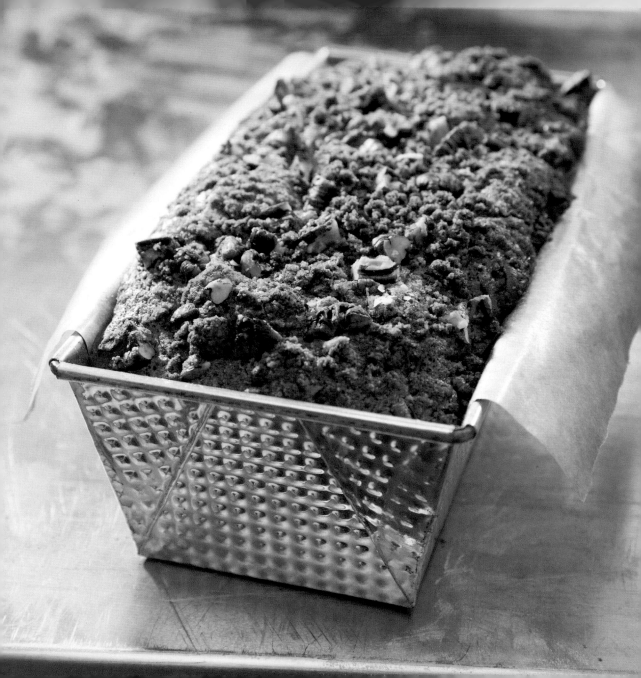

Rhubarb Streusel Bread

• •

This is adapted from a much-beloved recipe from my late Aunt Sharon,
given to me by her dietitian daughter, Julie, who also loves to bake.

• •

makes 2 loaves

BATTER
2½ cups all-purpose flour
1 teaspoon baking soda
1 teaspoon salt
1½ cups light brown sugar
1 cup buttermilk
½ cup vegetable oil
1 teaspoon vanilla extract
1 egg
1½ cups chopped rhubarb
 (about 4 medium-size stalks,
 cut into ¼-inch pieces)

STREUSEL
2 tablespoons granulated sugar
2 tablespoons light brown sugar
1 tablespoon all-purpose flour
1½ teaspoons cinnamon
1 tablespoon butter, melted
½ cup chopped pecans

Preheat oven to 350 degrees. Line with parchment paper or grease and flour 2 (8x4-inch) loaf pans or 1 (12x4-inch) loaf pan.

To make batter, sift together flour, baking soda, and salt in a medium-size bowl. In the bowl of a stand-up electric mixer, beat brown sugar, buttermilk, oil, and vanilla until moistened. Add egg; mix just until combined. Add flour mixture. Stir in rhubarb.

To make streusel, stir together sugars, flour, cinnamon, butter, and pecans until crumbly.

Divide half of the batter between prepared pans. Top each with half of the streusel mixture. Spread remaining half of the batter into pans, and top with remaining half of the streusel mixture.

Bake for 50 minutes or until a wooden pick inserted in center of bread comes out clean. Cool in pans for 5 minutes. Gently invert to remove; continue to cool before serving.

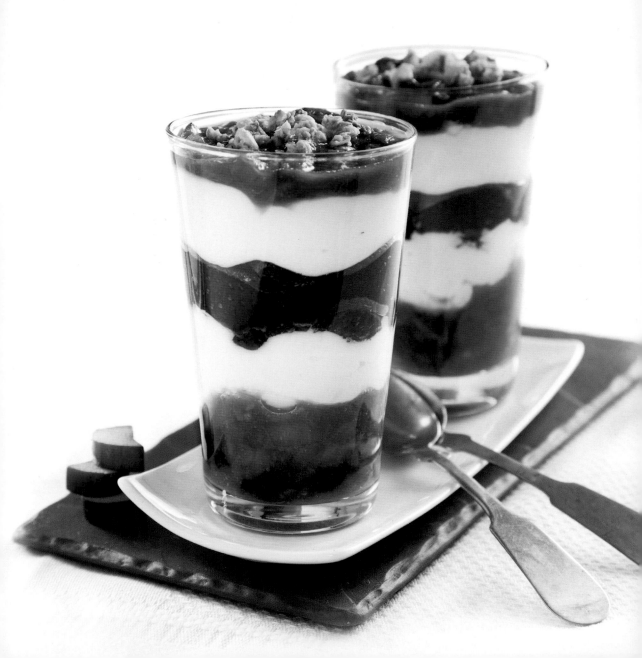

Rhubarb Parfait

..

makes 2 servings

SAUCE
4 cups chopped rhubarb
 (about 8–10 medium-size
 stalks, cut into ½-inch pieces)
½ cup sugar
2–3 tablespoons water

FILLING
1 cup plain Greek yogurt
3 tablespoons honey
2¼ teaspoons vanilla extract

TOPPINGS
½ cup fresh strawberries, hulled
 and sliced
¼ cup granola

To make sauce, combine rhubarb, sugar, and 2–3 tablespoons water in a large pan over medium-high heat. Cook, stirring frequently, 7–10 minutes or until rhubarb is tender. Cool.

To make filling, combine Greek yogurt, honey, and vanilla in a small bowl.

In 2 medium-size parfait glasses, layer half of the sauce mixture, half of the filling mixture, strawberries, remaining half of the filling mixture, and remaining half of the sauce mixture. Top with granola.

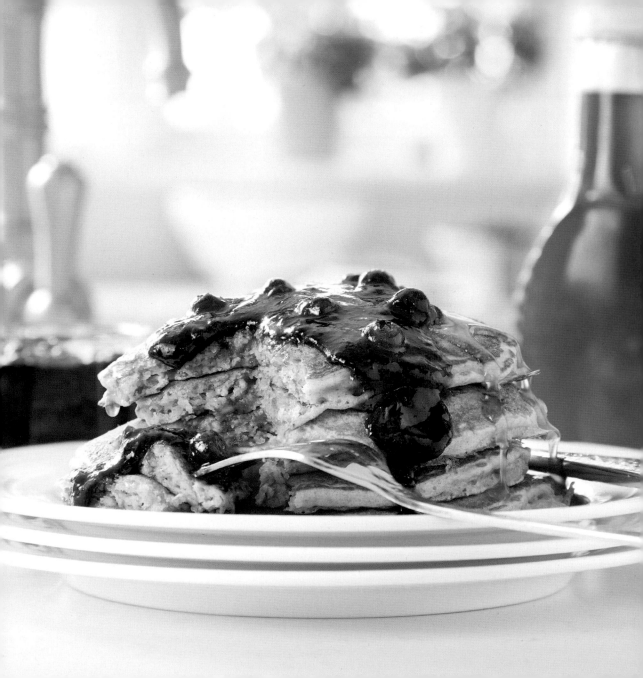

Rhubarb-Blueberry Breakfast Sauce *GF

••

makes 2 cups

INGREDIENTS

2 cups chopped rhubarb
 (about 3–5 medium-size
 stalks, cut into ½-inch pieces)
2 cups blueberries, divided
7 tablespoons sugar
5 tablespoons water
1 tablespoon honey
1 tablespoon cornstarch
1 tablespoon lemon juice

Combine rhubarb, ½ cup blueberries, sugar, 5 tablespoons water, and honey in a large saucepan over high heat. Bring to a boil, and then simmer 5 minutes. Mash remaining 1½ cups blueberries; add to rhubarb mixture. In a small bowl, whisk together cornstarch and lemon juice. Add cornstarch mixture to saucepan; return to a boil, and simmer 2 minutes. Cool. Spoon mixture into sterilized glass jars with lids. Refrigerate up to 1 week or freeze in airtight containers.

pies

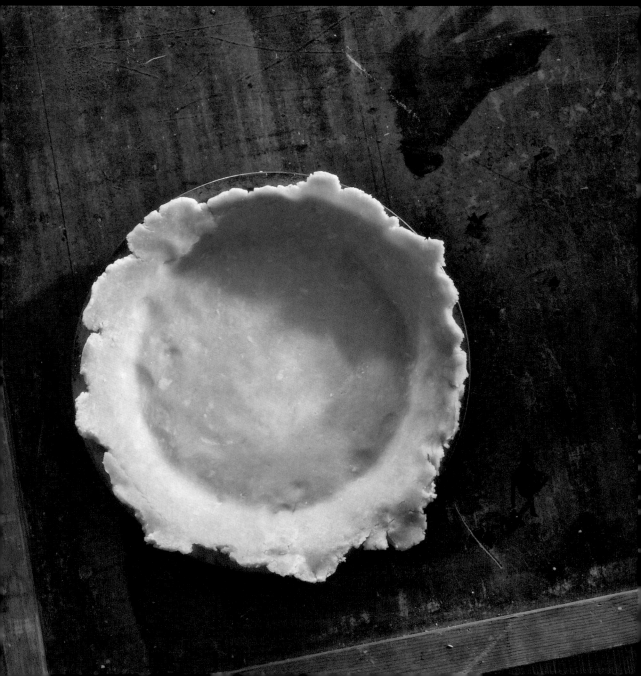

Best Double Piecrust

This basic crust recipe is the best of all the many that I have tested. This crust is flaky, just flavorful enough, and also rolls out nicely. A nod and a thank you to Donna Hawkins and her Chickadee Cottage Cafe. For best results when rolling out the dough, let it rest at room temperature for 10 minutes. Lightly flour both your work surface and your rolling pin. Slowly rotate the dough every couple of rolls to help it spread out evenly. When desired size and thickness are reached, fold dough into fourths; position in pie plate, and then unfold and press gently to fit. Or roll the dough onto the rolling pin and unroll it into the pie plate.

makes 2 piecrusts

INGREDIENTS
2½ cups all-purpose flour
½ teaspoon salt
1 tablespoon sugar
8 tablespoons unsalted butter, cubed and frozen
8 tablespoons butter-flavored shortening, cubed and frozen
1 tablespoon apple cider vinegar
½ cup ice water

Place flour, salt, and sugar in the bowl of a food processor with a metal blade; pulse twice to combine. Sprinkle frozen butter and shortening pieces over flour mixture. Pulse to cut butter and shortening into flour (mixture should resemble coarse crumbs).

Combine vinegar with ice water in a small bowl. Sprinkle 3 tablespoons ice-water mixture over flour, and pulse; continue, adding 1 tablespoon ice-water mixture and pulsing each time until flour gathers and dough is moistened. Place loose, crumbly dough on a lightly floured surface. Knead gently into a smooth ball.

Divide into two dough balls. Flatten and wrap each dough disk in plastic wrap. Refrigerate 30 minutes to overnight.

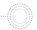 *Butter pieces should remain visible in the dough.*

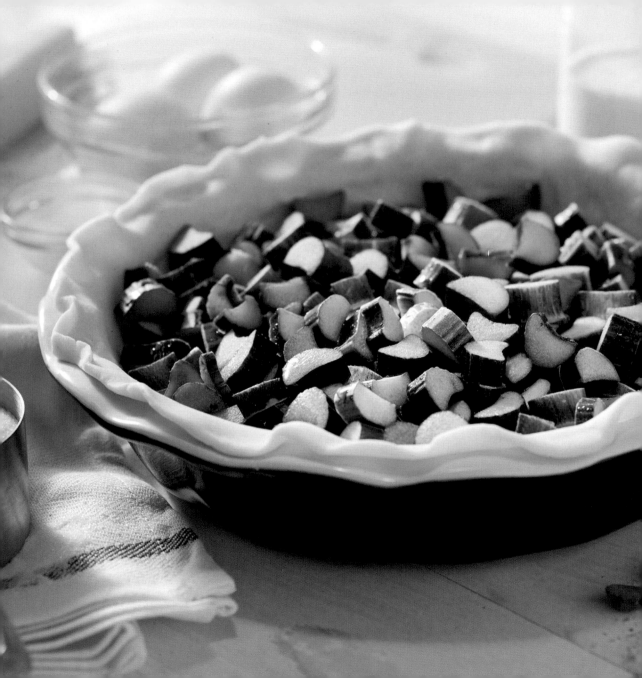

Grandma's Rhubarb Custard Pie

· ·

This is a favorite rhubarb pie for many. An equal amount of dried nutmeg
may be substituted, but freshly grated is better.

· ·

makes 8 servings

INGREDIENTS

½ Best Double Piecrust
 (page 49) or ½ package
 store-bought refrigerated
 piecrust dough
3 large eggs
3 tablespoons half-and-half
1½ cups sugar
2 tablespoons all-purpose flour
¼ teaspoon freshly grated
 nutmeg
¼ teaspoon salt
4 cups chopped rhubarb
 (about 8–10 medium-size
 stalks, cut into ½-inch pieces)

Preheat oven to 450 degrees.

Roll out 1 disk chilled piecrust dough into an 11-inch circle.
Line a 9-inch pie plate with dough, and flute edges; chill.

In a large bowl, slightly beat together eggs and half-and-half.
In a separate bowl, combine sugar, flour, nutmeg, and salt.
Stir flour mixture into egg mixture. Add rhubarb, stirring
to coat.

Pour rhubarb mixture into prepared piecrust. Bake for
15 minutes. Reduce oven temperature to 350 degrees;
bake for 25–30 minutes or until custard is set and rhubarb
is tender. (Test with a knife inserted in the center.) Bake in
5-minute additional increments, if necessary, until done.

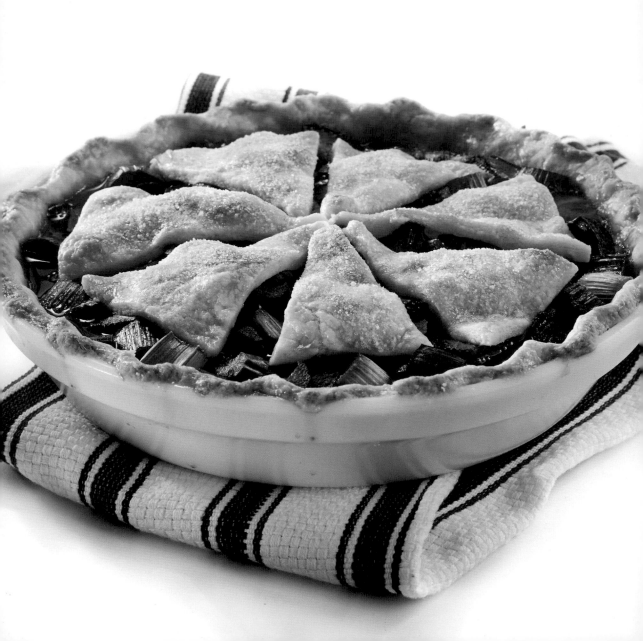

Strawberry–Rhubarb Pie

··

makes 8 servings

INGREDIENTS

1 Best Double Piecrust
 (page 49)
3 cups chopped rhubarb
 (about 6–8 medium-size
 stalks, cut into ½-inch pieces)
2 cups strawberries, hulled
 and halved
1½ cups granulated sugar
2 tablespoons instant tapioca
1 tablespoon all-purpose flour
½ teaspoon lemon zest
½ teaspoon fresh lemon juice
½ teaspoon cinnamon
1 teaspoon vanilla extract
1 tablespoon cold butter,
 cut into small pieces
1 egg
1 tablespoon cold water
Raw or large-crystal sugar

Preheat oven to 425 degrees.

Roll out 1 disk chilled piecrust dough into an 11-inch circle. Line a 9-inch pie plate with dough, and flute edges; chill. Roll out remaining dough disk in a circle, and cut into 6–8 triangles. (See photo; triangles will shrink while baking.)

Gently mix rhubarb, strawberries, sugar, tapioca, flour, lemon zest and juice, cinnamon, and vanilla in a large bowl. Pour rhubarb mixture into prepared piecrust, and dot with butter.

Arrange piecrust triangles on top. Whisk egg and 1 table-spoon cold water together in a small bowl. Brush piecrust triangles with egg mixture, and sprinkle with raw or large-crystal sugar. Bake for 15 minutes; lower oven temperature to 375 degrees, and bake for 45 minutes, checking after 30 minutes and shielding outer crust with aluminum foil, if necessary, to prevent excessive browning.

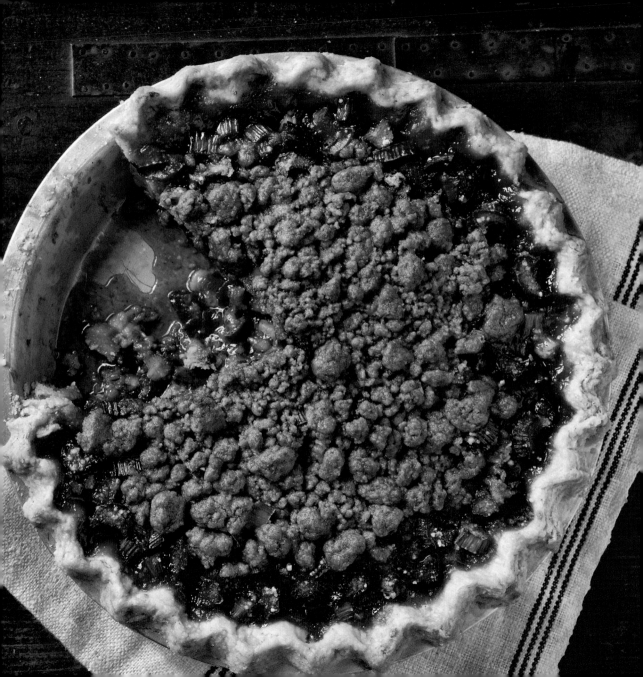

Rhubarb Streusel Pie

FILLING

½ Best Double Piecrust
 (*page 49*)
6 cups chopped rhubarb
 (about 12–15 medium-size
 stalks, cut into ½-inch pieces)
1 cup granulated sugar
3 tablespoons instant tapioca
1 tablespoon orange zest
2 tablespoons fresh orange juice
2 teaspoons vanilla extract
¼ teaspoon cinnamon
¼ teaspoon salt

STREUSEL

½ cup all-purpose flour
⅓ cup light brown sugar
½ teaspoon cinnamon
4 tablespoons butter

Preheat oven to 400 degrees.

Roll out 1 disk chilled piecrust dough into an 11-inch circle. Line a 9-inch pie plate with dough, and flute edges. Chill in freezer.

To make filling, combine rhubarb, granulated sugar, tapioca, orange zest and juice, vanilla, cinnamon, and salt. Spoon rhubarb mixture into piecrust. Bake for 30 minutes.

Meanwhile, to make streusel, place flour, brown sugar, cinnamon, and butter in the bowl of a food processor with a metal blade; pulse until crumbly. Remove pie from oven, and sprinkle evenly with streusel mixture. Lower oven temperature to 350 degrees, and bake for 25 minutes, shielding crust with aluminum foil, if necessary, to prevent excessive browning.

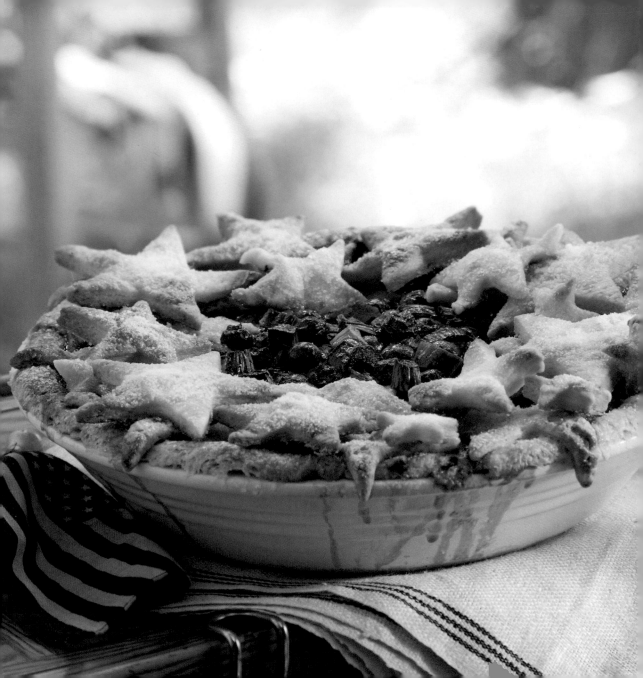

Fourth of July Blubarb Pie

This fun-to-make, patriotic pie pairs nicely with vanilla ice cream.

makes 8 servings

INGREDIENTS

1 Best Double Piecrust
 (page 49)
4 cups chopped rhubarb
 (about 8–10 medium-size
 stalks, cut into ½-inch pieces)
2 cups blueberries
Juice of half a lemon
⅓ cup all-purpose flour
1 cup granulated sugar
1 tablespoon butter, cut into
 small pieces
1 egg
2 tablespoons cream
White sanding sugar

Roll out 1 disk chilled piecrust dough into an 11-inch circle. Line a 9-inch pie plate with dough, and flute edges; chill. Roll out remaining dough disk, and cut out about 13 stars in various sizes. Chill.

Preheat oven to 350 degrees.

In a large bowl, combine rhubarb, blueberries, lemon juice, flour, and granulated sugar; gently toss to coat. Spoon rhubarb mixture into piecrust, and dot with butter pieces. Whisk together egg and cream in a small bowl. Using egg mixture, attach piecrust stars around edges of pie (see photo). Brush tops and edges with egg mixture; sprinkle with white sanding sugar.

Transfer pie to a rimmed baking sheet. Bake for 1 hour or until pastry is golden brown and fruit is bubbling, shielding edges with aluminum foil, if necessary, to prevent excessive browning.

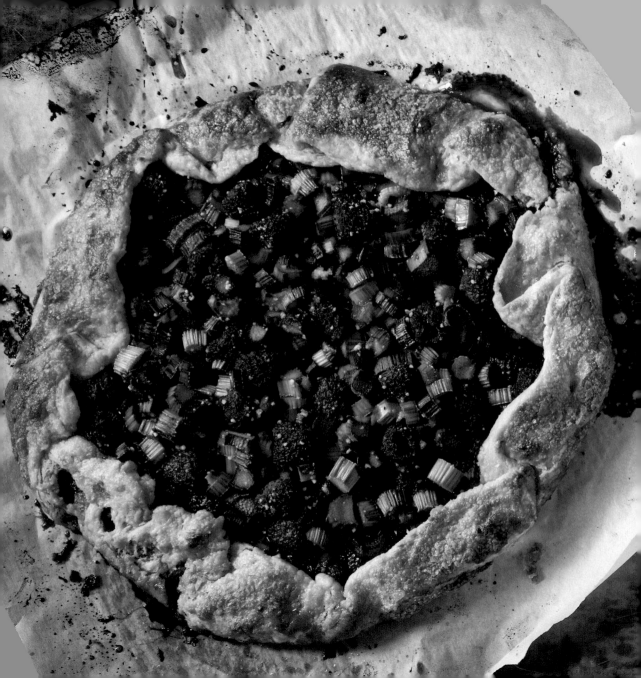

Rhubarb Galette

makes 6–8 servings

INGREDIENTS

3 tablespoons sour cream
⅓ cup ice water
1 cup all-purpose flour
¼ cup yellow cornmeal
¾ cup plus 1 teaspoon sugar, divided
½ teaspoon salt
7 tablespoons butter, sliced and frozen
2 tablespoons Rhubarb Jam (page 115 or store-bought)
2 cups chopped rhubarb (about 3–5 medium-size stalks, cut into ½-inch pieces)
1 cup fresh raspberries
1 tablespoon lemon juice
1 tablespoon instant tapioca
Sugar

Whisk together sour cream and ice water in a small bowl. Place flour, cornmeal, 1 teaspoon sugar, and salt in the bowl of a food processor with a metal blade; pulse twice to combine. Add frozen butter pieces, and process until butter is pea-sized and mixture is crumbly. With the machine running, add sour cream mixture until a soft dough forms. Remove dough and form into a disk; wrap tightly in plastic wrap. Chill 2 hours.

Preheat oven to 400 degrees.

Line a rimmed baking sheet with parchment paper. Roll out chilled dough disk on a floured surface into an 11-inch circle. Transfer to prepared baking sheet. Spread crust with jam, leaving a 2-inch border.

Combine rhubarb, raspberries, lemon juice, remaining ¾ cup sugar, and tapioca, tossing gently to coat. Spoon rhubarb mixture into middle of piecrust, leaving a 2- to 3-inch border. Fold piecrust border up over filling, allowing dough to pleat (see photo). Use a pastry brush dipped in water to secure the pleats. Sprinkle pleated edge generously with sugar.

Bake for 35–40 minutes or until crust is golden brown.

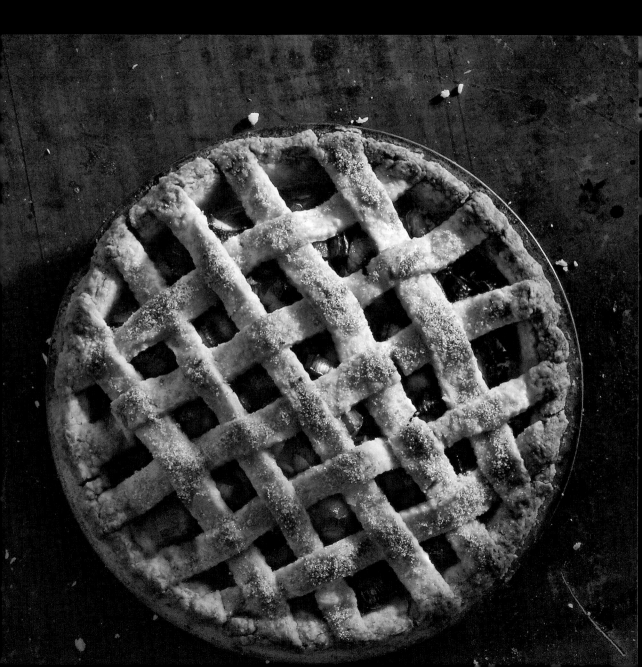

Peach–Rhubarb Pie

makes 8 servings

INGREDIENTS

2 cups chopped rhubarb
 (about 3–5 medium-size
 stalks, cut into ½-inch pieces)
2 cups peeled and sliced peaches
 (3–4 peaches)
1 cup sugar
3 tablespoons instant tapioca
¼ cup orange juice or Grand
 Marnier
2 tablespoons butter, melted
1 Best Double Piecrust
 (page 49)
1 egg
1 tablespoon cold water
Raw or large-crystal sugar

In a large bowl, combine rhubarb, peaches, sugar, tapioca, orange juice, and butter. Cover and let stand.

Preheat oven to 375 degrees.

Roll out 1 disk chilled piecrust dough into an 11-inch circle. Line a 9-inch pie plate with dough. Spoon rhubarb mixture into piecrust, and trim piecrust dough ½ inch beyond edge of pie plate.

Roll remaining dough disk into a circle, and cut into ½-to ¾-inch-wide strips. Create a lattice top over rhubarb mixture, crimping edges as desired (see page 18). Whisk together egg and 1 tablespoon cold water in a small bowl; brush egg mixture over piecrust. Sprinkle lightly with raw or large-crystal sugar.

Bake for 25 minutes, shielding edges with aluminum foil. Remove foil, and bake 25–30 more minutes or until top is golden and filling is bubbly.

To make individual servings, double the rhubarb mixture. Fill 8 (1-cup) ramekins with rhubarb mixture, and top each with a circle of piecrust dough. Place ramekins on a rimmed baking sheet. Bake at 375 degrees for 45 minutes or until tops are golden and filling is bubbly.

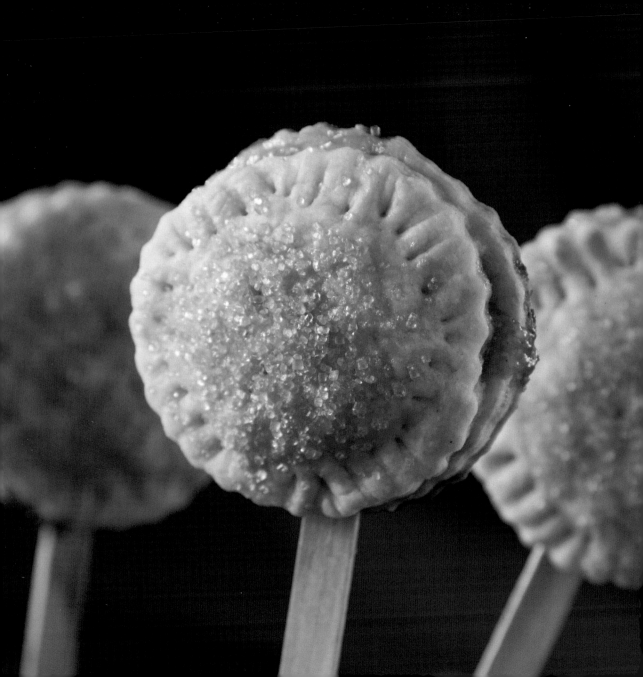

Rhubarb Hand-Pie Pops

makes 8 servings

INGREDIENTS

3 cups chopped rhubarb
 (about 6–8 medium-size
 stalks, cut into ½-inch pieces)
1 can apple pie filling
½ cup granulated sugar
½ teaspoon ginger
½ teaspoon nutmeg
1 Best Double Piecrust
 (page 49)
1 egg
1 tablespoon cold water
Raw or large-crystal sugar

In a large saucepan over medium-high heat, combine rhubarb, apple pie filling, granulated sugar, ginger, and nutmeg. Bring to a boil; reduce heat, and simmer 6 minutes. Cool.

Roll each dough disk between wax or parchment paper to ¼-inch thickness. Cut out 16 circles with a 2½-inch fluted-edge cutter. Place 8 dough circles on a parchment paper-lined baking sheet. Place a wooden treat stick on lower half of each circle. Spoon 1 tablespoon rhubarb mixture in center of each circle; wet dough edges with water. Place remaining 8 dough circles over rhubarb mixture; seal edges with a fork. Chill 10 minutes.

Preheat oven to 350 degrees.

Whisk together egg and 1 tablespoon cold water in a small bowl; brush hand pies with egg mixture, and sprinkle with raw or large-crystal sugar. Bake for 20 minutes or until golden brown, shielding wooden treat sticks with aluminum foil, if necessary.

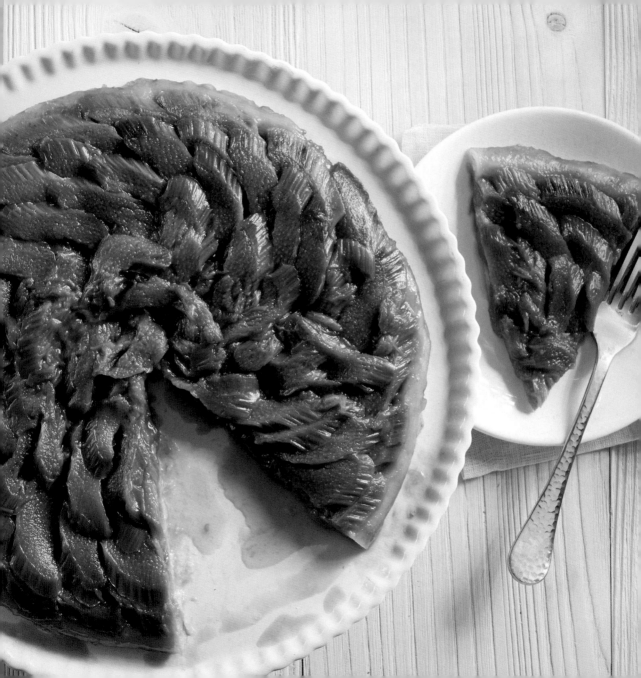

Rhubarb Tarte Tatin

••

This famous French dessert is usually made with apples. I'd been making it that
way for years, so I thought…why not try it with rhubarb? It was *délicieux!*

••

makes 6–8 servings

INGREDIENTS

¾ cup sugar
2 tablespoons water
1 teaspoon lemon juice
1 teaspoon vanilla extract
3 tablespoons butter
2 cups sliced rhubarb
 (about 3–5 medium-size
 rhubarb stalks, cut into
 ¼-inch-thick angled pieces)
½ Best Double Piecrust
 (page 49)

In a 10-inch, slope-sided, ovenproof sauté pan over medium-high heat, combine sugar, water, lemon juice, and vanilla. Bring to a boil, stirring until sugar dissolves and syrup becomes a pale caramel color. Remove from heat; add butter, and swirl to combine.

Add rhubarb pieces evenly to pan, forming two layers of slightly overlapping concentric circles (see photo). Return pan to stove; cook over medium heat until juices reduce to a thick glaze. Do not stir. Remove from heat.

Preheat oven to 375 degrees.

Roll dough disk into a 10-inch circle (size of ovenproof sauté pan). Place piecrust dough over rhubarb mixture in pan, and trim if needed. Pierce dough with a fork.

Bake for 20 minutes. Cool slightly. Invert a round cake plate or cake pedestal on top of pan; protecting your hands from the heat, hold pan and plate tightly together, and flip them over. Gently remove sauté pan after tarte has transferred to serving platter.

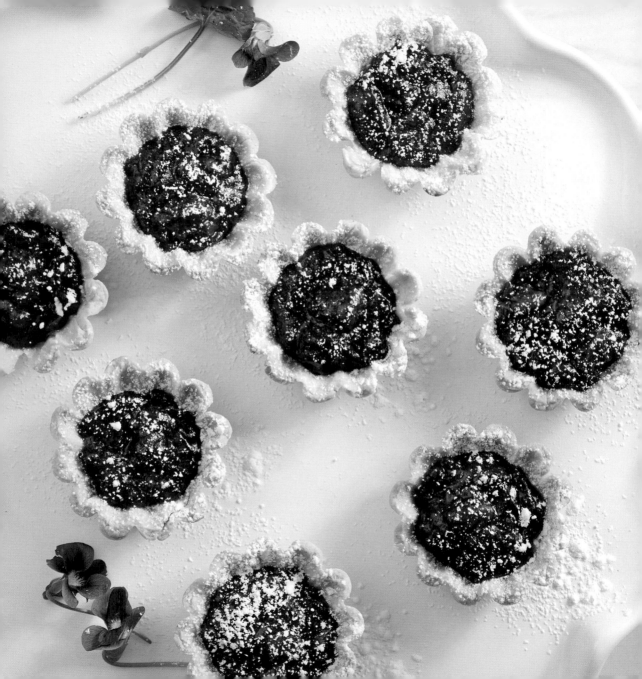

Mini Strawberry–Rhubarb Tarts

• •

These little pies are easy to make and oh-so-fun to eat. If you'd like to make your own tart shells, bake homemade or store-bought refrigerated piecrust dough in mini tart pans.

• •

makes 6–9 servings

INGREDIENTS:
18 store-bought mini tart shells
¾ cup chopped rhubarb (about 2 medium-size stalks, cut into ½-inch pieces)
1 cup strawberries, finely chopped
¼ cup granulated sugar
Juice of a small orange
1 tablespoon cornstarch
1 tablespoon water
Powdered sugar

Bake shells according to package directions; cool.

In a saucepan over medium-high heat, combine rhubarb, strawberries, granulated sugar, and orange juice. Bring rhubarb mixture to a boil; once rhubarb is soft, reduce heat to simmer. Whisk together cornstarch and 1 tablespoon water in a small bowl; stir cornstarch mixture into rhubarb mixture until thickened. Remove from heat; cool, and spoon into tart shells. Chill. Sprinkle with powdered sugar before serving.

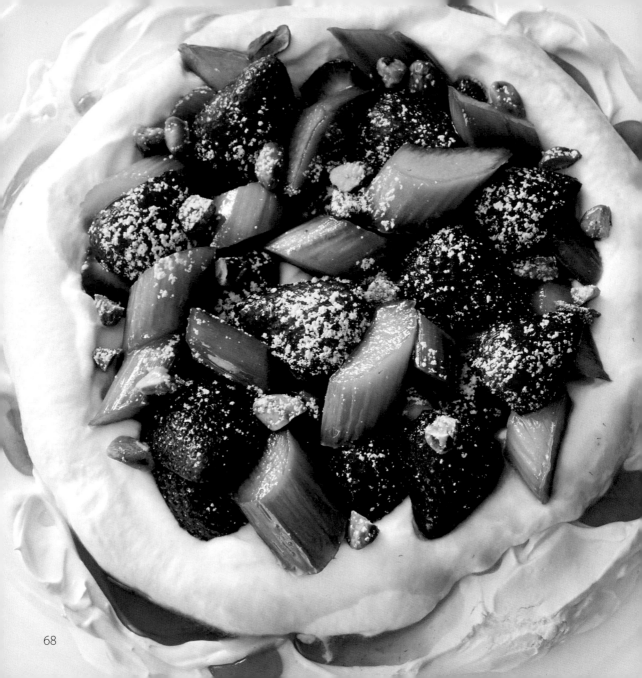

desserts
cakes, cookies, bars

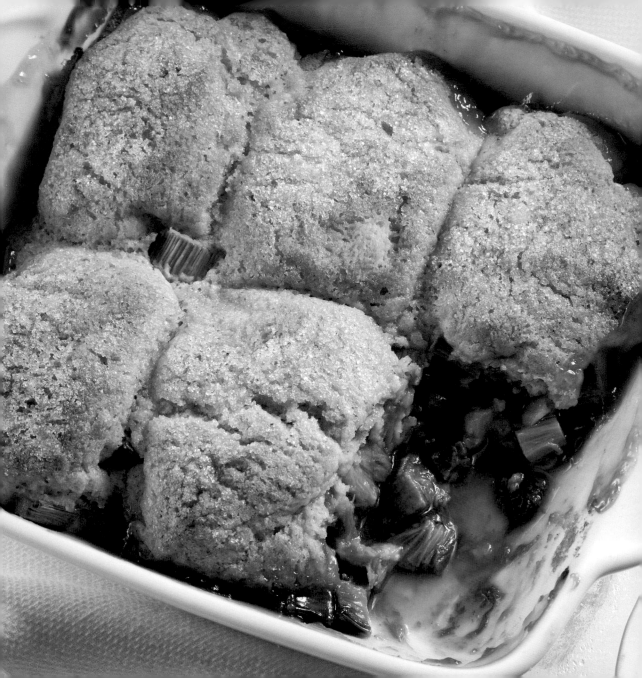

Rhubarb Cobbler

· ·

makes 4–6 servings

FILLING

4 cups chopped rhubarb
 (about 8–10 medium-size
 stalks, cut into ½-inch pieces)
½ cup granulated sugar
1 tablespoon cornstarch
1 teaspoon orange zest

BATTER

¾ cup all-purpose flour
⅛ cup granulated sugar
¾ teaspoon baking powder
¼ teaspoon baking soda
¼ teaspoon salt
¼ teaspoon cinnamon
¼ teaspoon ginger
¼ teaspoon nutmeg
2 tablespoons cold butter,
 cut into small pieces
1 cup buttermilk
¼ teaspoon vanilla extract
Raw or large-crystal sugar

To make filling, combine rhubarb, granulated sugar, corn-starch, and orange zest in a large bowl. Allow rhubarb mixture to set 30 minutes. Transfer into a buttered 9x9-inch baking pan.

Preheat oven to 375 degrees.

To make batter, combine flour, granulated sugar, baking powder, baking soda, salt, cinnamon, ginger, and nutmeg in the bowl of a food processor with a metal blade; pulse twice to combine. Sprinkle butter over flour mixture; pulse until mixture resembles coarse crumbs. Add buttermilk and vanilla. Pulse until a sticky dough is formed.

Drop crust batter in large spoonfuls over rhubarb mixture in pan. Sprinkle with raw or large-crystal sugar. Bake for 30–35 minutes or until crust is golden brown and filling is bubbling.

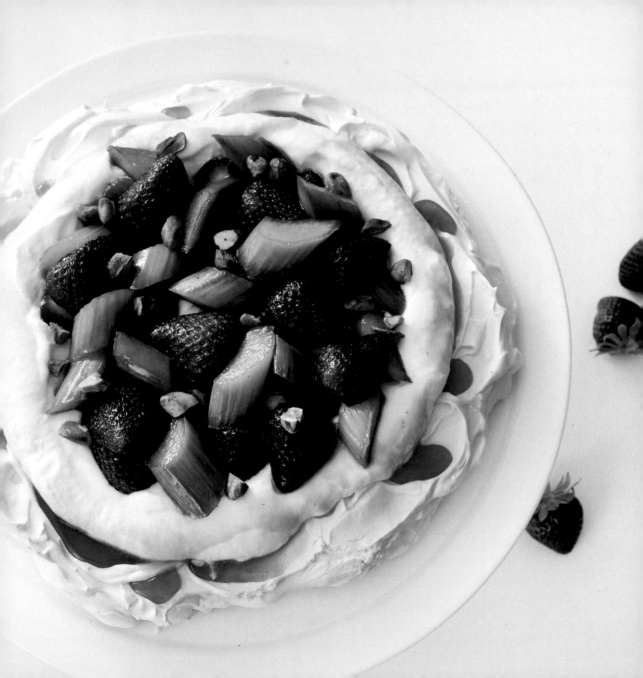

Pavlova with Rhubarb, Strawberries, and Fresh Cream *GF

makes 8 servings

INGREDIENTS

5 large egg whites or 4 extra-large egg whites, brought to room temperature
1 cup superfine sugar
1 teaspoon distilled white vinegar
½ teaspoon vanilla extract
⅛ teaspoon fine sea salt
8 teaspoons cornstarch
3 tablespoons Amaretto or Drambuie liqueur
3 tablespoons honey
¾ cup sliced rhubarb (about 2 medium-size stalks, cut into 1-inch slices)
1 cup strawberries, hulled and halved
1 cup whipping cream
1 teaspoon almond extract
1 tablespoon powdered sugar
2 tablespoons chopped pistachios

Position oven rack in bottom of oven and preheat to 300 degrees. Line a large baking sheet with parchment paper. Using a pencil, draw an 8-inch circle in the middle.

In the bowl of a stand-up electric mixer with whip attachment, beat egg whites, superfine sugar, vinegar, vanilla, and salt at medium speed until stiff peaks form (about 18 minutes). Sift cornstarch over bowl and fold into egg mixture. Dollop egg mixture into center of circle. Swirl mixture outward toward edges of circle, making an indentation in the middle. Place in oven, reduce temperature to 225 degrees, and bake for 1 hour. Turn oven off. Prop oven door open; let cool 30 minutes. Remove from oven, and cool completely on a serving platter.

Meanwhile, bring Amaretto and honey to a simmer in a medium-size saucepan over medium-high heat. Add rhubarb; simmer 1 minute, and remove from heat. Allow to set 5 minutes. Add strawberries, and stir gently to coat; allow fruit mixture to set for 30 minutes.

In the clean, chilled bowl of a stand-up electric mixer with whip attachment, whip cream and almond extract. Sift powdered sugar over cream mixture. Continue whipping cream until soft peaks form. Spoon whipped cream onto cooled pavlova. Arrange fruit mixture on top, reserving juices. Sprinkle with nuts and drizzle with juices just before serving.

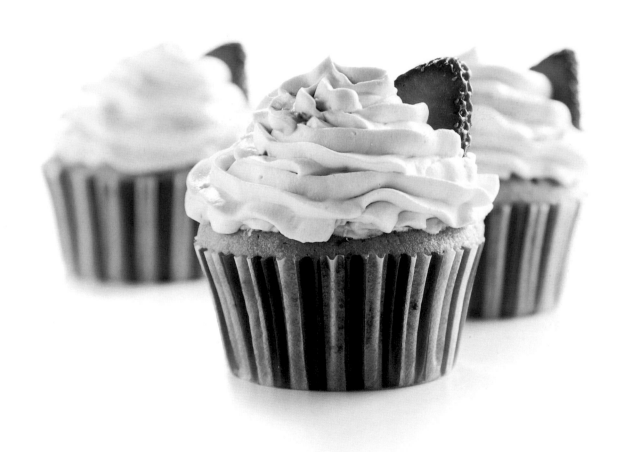

Rhubarb Cupcakes with Strawberry Frosting

makes 12 cupcakes

BATTER

1½ cups all-purpose flour
¼ teaspoon baking powder
¼ teaspoon baking soda
⅛ teaspoon salt
½ cup unsalted butter, softened
1 cup granulated sugar
2 large eggs
1 teaspoon vanilla extract
½ cup sour cream
2 cups diced rhubarb
 (about 3–5 medium-size
 stalks, cut into ¼-inch
 pieces)

FROSTING

1 cup unsalted butter, softened
12 ounces cream cheese,
 at room temperature
4 cups powdered sugar
¾ teaspoon vanilla extract
2 tablespoons strawberry
 preserves

Preheat oven to 350 degrees.

To make batter, whisk together flour, baking powder, baking soda, and salt in a medium-size bowl. In the bowl of a stand-up electric mixer, cream softened butter and granulated sugar until fluffy. Add eggs, one at a time, beating until blended after each addition. Add vanilla. Reduce speed to low. Stir in flour mixture in two batches, alternating with sour cream. Beat until fully incorporated. Stir in rhubarb.

Place 12 cupcake liners in a muffin pan. Spoon batter into prepared pan, filling ¾ full. Bake for about 25 minutes or until done. Cool completely.

Meanwhile, to make frosting, beat softened butter and cream cheese until well blended. Add powdered sugar, ½ cup at a time, beating until well blended after each addition. Beat in vanilla and preserves until creamy. Frost cooled cupcakes.

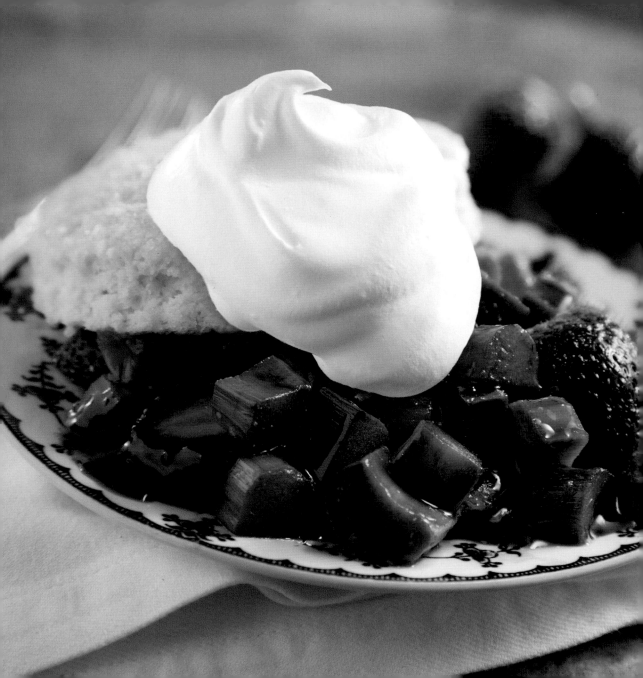

Rhubarb–Strawberry Shortcake

..

makes 6 servings

SAUCE

2 cups sliced rhubarb
 (about 3–5 medium-size
 stalks, cut into ½-inch pieces)
6 tablespoons sugar
¼ teaspoon cinnamon
10 strawberries, hulled
 and halved

DOUGH

2¾ cups cake flour
¼ cup plus 1 tablespoon
 sugar, divided
1 tablespoon plus 1 teaspoon
 baking powder
1 teaspoon salt
10 tablespoons unsalted cold
 butter, cut into pieces
1 cup plus 3 tablespoons
 whipping cream, divided
Whipped cream topping or
 sweetened whipped cream

To make sauce, combine rhubarb, sugar, cinnamon, and strawberries in a medium-size saucepan over medium heat. Cook, stirring occasionally, until sauce is slightly thickened and fruit is cooked but intact; set aside.

Preheat oven to 425 degrees.

To make dough, place flour, ¼ cup sugar, baking powder, and salt in the bowl of a food processor with a metal blade; pulse twice to combine. Add butter, and process just until crumbly. While machine is running, add 1 cup cream through the chute; process just until dough forms a ball. Transfer dough to a floured sheet of wax paper. Using lightly floured fingers, pat dough to an even 1- to 2-inch thickness.

Cut dough into 6 (3-inch) circles using a floured fluted cutter. Place dough circles on a parchment paper-lined baking sheet. Brush tops with remaining 3 tablespoons cream, and sprinkle with remaining 1 tablespoon sugar.

Bake for 12–15 minutes or until dough rises and turns a very light brown on the bottom; cool. Split shortcakes with a serrated knife or a fork. Spoon rhubarb sauce evenly on bottom halves of shortcakes; top with upper halves and whipped cream topping.

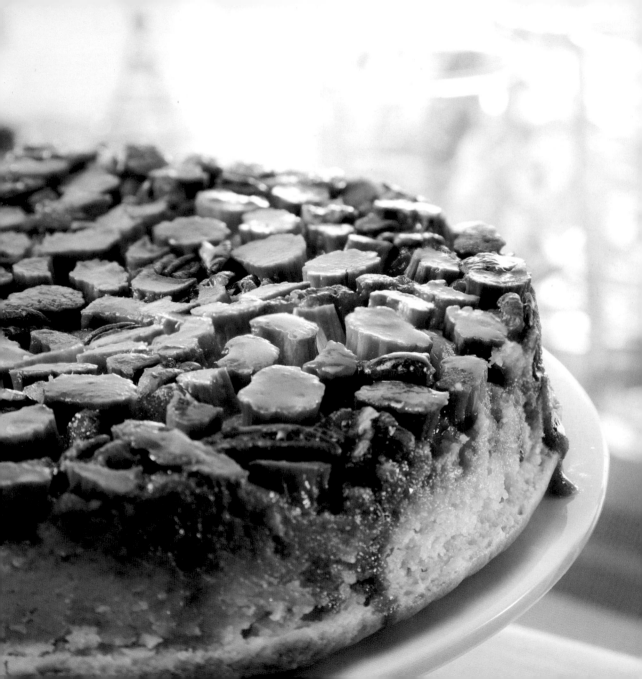

Rhubarb Upside-down Cake

This recipe was adapted from *Baking with Julia* by Dorie Greenspan.

makes 1 (10-inch) round cake

INGREDIENTS

12 tablespoons unsalted butter, softened and divided
½ cup dark brown sugar
1 tablespoon bourbon
2 tablespoons chopped pecans
3 cups sliced rhubarb (about 6–8 medium-size stalks, cut into ½-inch pieces)
1⅔ cups all-purpose flour
2 teaspoons baking powder
1 teaspoon salt
2 teaspoons vanilla extract
1 cup sour cream or crème fraiche
1 cup granulated sugar
2 large eggs, at room temperature

Melt 4 tablespoons butter in a medium-size saucepan over medium heat; add brown sugar and bourbon, and cook until brown sugar melts and mixture becomes caramel colored. Stir in pecans to coat. Scrape caramel-pecan mixture into a buttered and lightly floured 10-inch springform pan. Arrange rhubarb, cut sides down, in pan.

Preheat oven to 350 degrees.

Whisk together flour, baking powder, and salt in a medium-size bowl. In a separate bowl, combine vanilla and sour cream.

Cream remaining 8 tablespoons butter and granulated sugar in the bowl of a stand-up electric mixer. Add eggs, one at a time, beating until blended after each addition. Fold in flour mixture and vanilla mixture alternately, ending with flour mixture.

Spoon batter over rhubarb in pan; smooth top with a spatula. Bake for 20–25 minutes or until a wooden pick inserted in center comes out clean. Invert onto a serving plate.

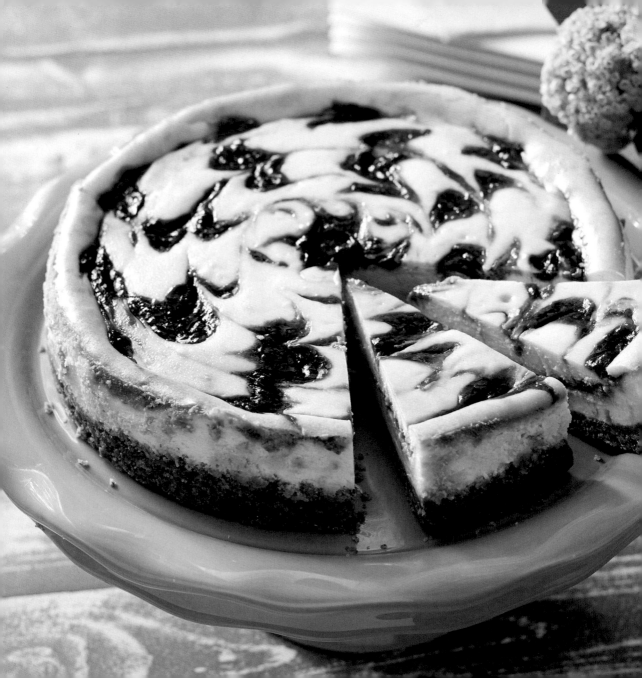

Rhubarb Cheesecake

• •

It is essential that the eggs, sour cream, and cream cheese start at room temperature if you want to make a successful cheesecake. I achieved my design by spooning 8 equal dollops of the rhubarb mixture on top (placing one in the middle) and then making smaller dollops in between the 8. I then used a wooden skewer to pull through the dollops (like cutting a pie), staying above the graham cracker crust. I then pulled the skewer through the dollops in three concentric circles.

• •

makes 8–10 servings

INGREDIENTS

2½ cups chopped rhubarb
 (4–6 stalks, cut into ½-inch
 pieces)
1⅓ cups sugar, divided
2 tablespoons orange juice
2 cups crushed graham crackers
 (14 whole crackers)
¼ cup butter, melted
4 (8-ounce) packages of cream
 cheese, softened and at room
 temperature
½ cup sour cream, at room
 temperature
1 tablespoon cornstarch
2 teaspoons vanilla extract
¼ teaspoon salt
3 large eggs, at room
 temperature

Combine rhubarb, ⅓ cup sugar, and orange juice in a medium-size saucepan over medium-high heat; bring to a boil. Cook 10 minutes or until rhubarb is tender and sauce is thick. Remove rhubarb mixture from heat; cool.

In a medium-size bowl, combine graham crackers, ¼ cup sugar, and butter; press mixture into the bottom of a 10-inch springform pan. Wrap outside of pan with aluminum foil.

Preheat oven to 350 degrees.

In the bowl of a stand-up electric mixer, beat cream cheese, sour cream, remaining ¾ cup sugar, cornstarch, vanilla, and salt until well blended. Add eggs, one at a time, beating just until combined after each addition.

Pour half of cream cheese mixture into prepared crust in pan. Spoon 1 cup rhubarb mixture over cream cheese mixture, spreading evenly. Top with remaining half of cream cheese mixture. Dollop remaining rhubarb mixture on top. Gently swirl rhubarb mixture with a wooden skewer in an artful manner. Bake in a hot water bath or put a pan of hot water in the oven. Bake for 1 hour.

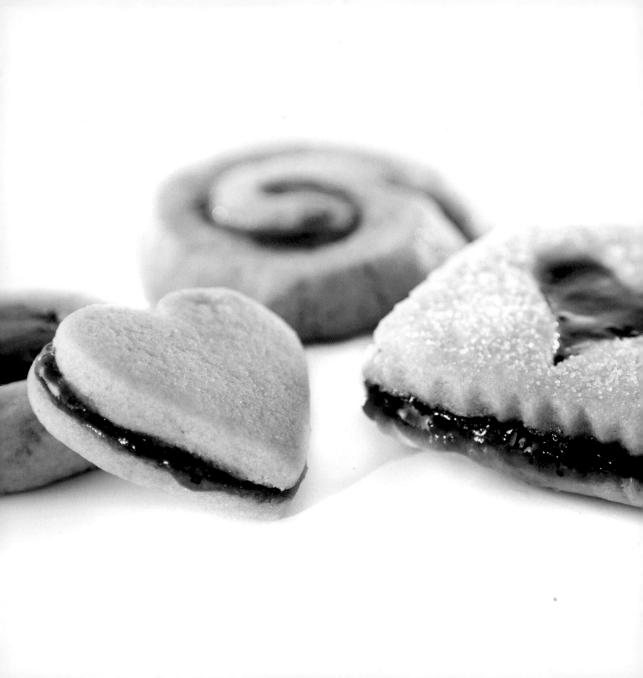

Rhubarb Jam Pinwheel Cookies

makes 4 dozen cookies

INGREDIENTS

16 tablespoons unsalted butter,
 softened
1 cup light brown sugar
1 cup granulated sugar
2 large eggs
1 teaspoon vanilla extract
4 cups all-purpose flour
1 teaspoon baking soda
½ teaspoon salt
1 cup Small-Batch Strawberry-
 Rhubarb Jam (page 121)

Beat butter in the bowl of a stand-up electric mixer until creamy; add sugars, and beat until light and fluffy. Add eggs and vanilla, and beat until blended. Add flour, baking soda, and salt; mix until combined.

Place half of the dough between sheets of wax paper, and roll into a 12x10-inch rectangle, ¼-inch thick. Remove top sheet of wax paper, and spread top of dough with ½ cup jam. Roll up dough, beginning at long side. Seal end and edges of dough. Wrap in wax paper, and chill 1–2 hours. Repeat procedure with remaining half of the dough and ½ cup jam.

Preheat oven to 350 degrees.

Cut dough into ¼-inch-thick slices. Place 2 inches apart on lightly greased baking sheets. Bake for 10 minutes. Cool on a wire rack before serving.

This dough can also be used for cut-out and thumbprint-style cookies.

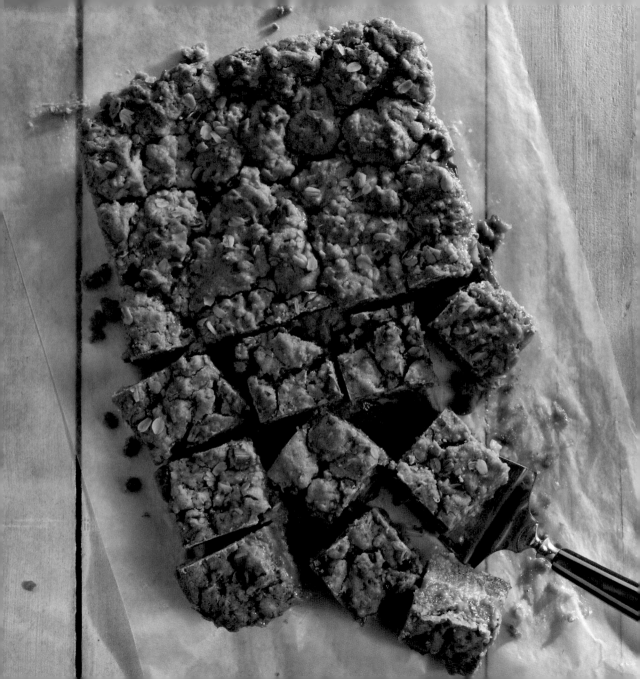

Rhubarb Oatmeal Cookie Bars

· ·

makes 2 dozen bars

FILLING

1 cup granulated sugar
2 teaspoons cornstarch
¾ cup water
6 cups chopped rhubarb
 (about 12–15 medium-size
 stalks, cut into ½-inch pieces)
1 cup cherry juice

DOUGH

2 cups all-purpose flour
1 teaspoon baking soda
1 teaspoon salt
1 teaspoon cinnamon
1¼ cups light brown sugar
16 tablespoons unsalted butter,
 softened
1 egg, lightly beaten
1 teaspoon vanilla extract
2 cups old-fashioned oats
1 cup pecans, chopped and
 lightly toasted

To make filling, whisk together granulated sugar, cornstarch, and ¾ cup water in a medium-size saucepan over medium heat; stir until sugar dissolves and mixture thickens. Stir in rhubarb and cherry juice; cook until mixture is thickened, about 5 minutes. Remove from heat, and allow filling mixture to cool.

Preheat oven to 350 degrees.

To make dough, whisk together flour, baking soda, salt, and cinnamon in a large bowl. Add brown sugar and butter; stir until combined. Mix in egg, vanilla, oats, and pecans.

Line a 9x13-inch baking pan with aluminum foil; lightly grease with cooking spray. Press three-quarters of the dough mixture into prepared pan. Spread filling mixture evenly over dough mixture in pan, and then crumble remaining dough mixture on top of filling mixture.

Bake for 40 minutes. Cool completely, and cut into 2-inch squares. Store in an airtight container up to 5 days.

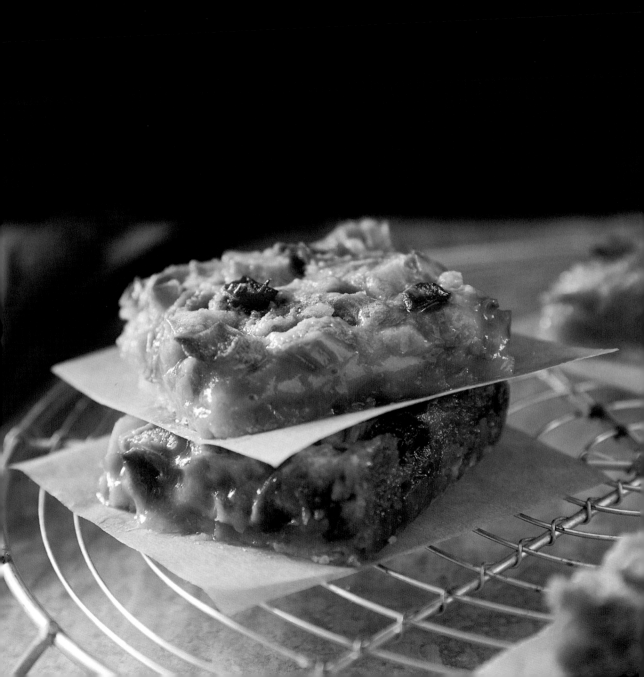

Rhubarb Dream Bars

With a delicious shortbread crust, this sweet but tart,
custard-style dessert bar is a very popular treat.

makes 16 bars

CRUST
1 cup all-purpose flour
3 tablespoons powdered sugar
8 tablespoons cold butter, cubed

FILLING
¼ cup all-purpose flour
1 cup light brown sugar
½ cup granulated sugar
½ teaspoon salt
2 large eggs
3 cups sliced rhubarb
 (about 6–8 medium-size
 stalks, cut into ¼-inch pieces)

Preheat oven to 350 degrees.

To make crust, place flour and powdered sugar in the bowl of a food processor with a metal blade; pulse twice to combine. Sprinkle butter on top; pulse until mixture resembles coarse crumbs. Line a 9x9-inch baking pan with aluminum foil or parchment paper. Press crust mixture evenly into prepared pan. Bake for 10–12 minutes or until lightly browned.

To make filling, combine flour, sugars, salt, and eggs in a large bowl. Gently stir in rhubarb. Pour filling mixture over baked crust in pan. Return pan to oven, and bake 30–40 minutes or until set. Cool 30 minutes, and then chill before cutting into 2x2-inch bars.

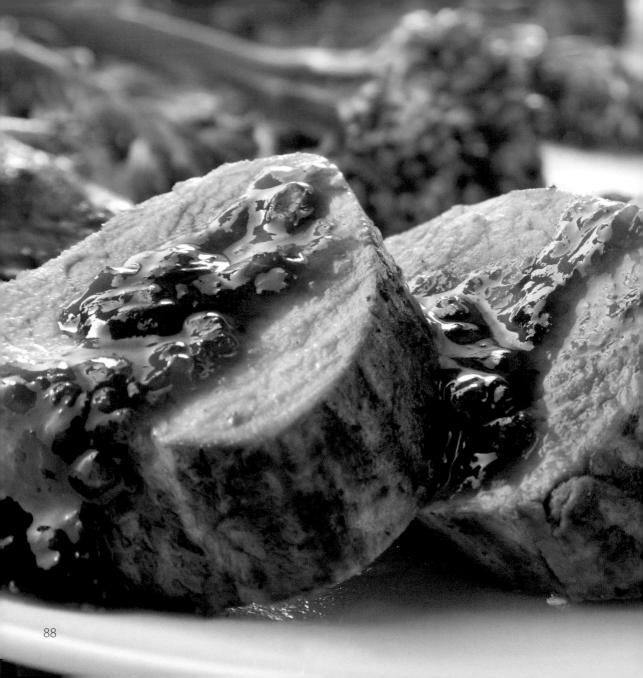

savory
mains, sides, sauces

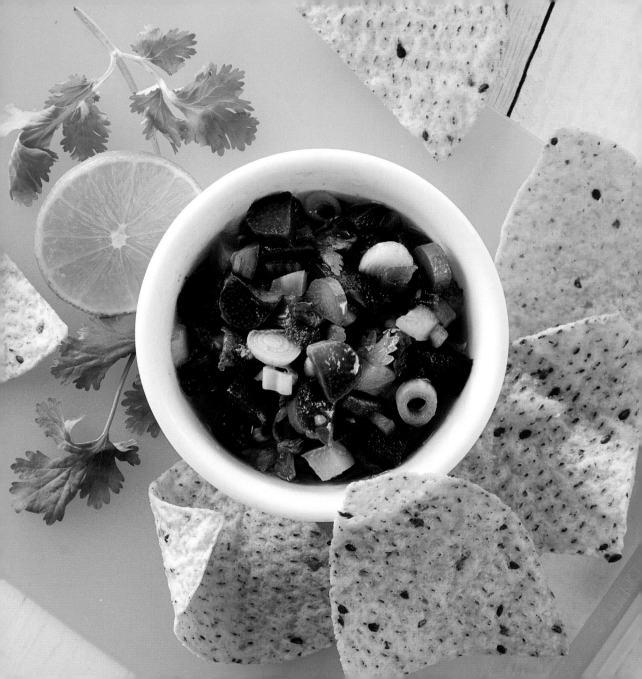

Rhubarb Salsa

This has some good heat; however, if you want more, substitute chili-flavored tomatoes, such as Rotel, for diced tomatoes.

makes 2 cups

INGREDIENTS

2 cups diced rhubarb
 (about 3–5 medium-size
 stalks, cut into ¼-inch pieces)
1 (10-ounce) can diced tomatoes
 with juice
½ cup chopped red bell pepper
½ cup chopped yellow bell
 pepper
¼ cup chopped cilantro
3 green onions, finely chopped
2 tablespoons seeded and
 minced jalapeño chili pepper
2 tablespoons lime juice
2 tablespoons light brown sugar
1 teaspoon salt
Ground black pepper to taste

Blanch rhubarb in a large pot of boiling water for 10 seconds. Strain under cold water; drain. Transfer rhubarb to a medium-size glass bowl. Stir in diced tomatoes and next 9 ingredients; mix well. Store in refrigerator 1 week.

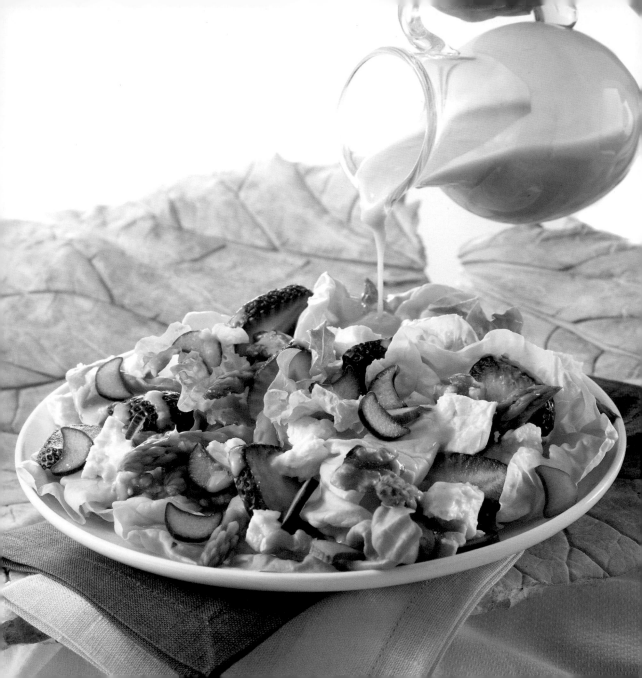

Rhubarb Party Salad

Vegetable or canola oil may be substituted for safflower oil, but remember to keep it light, so you don't overpower the rhubarb flavor. Prepare the Candied Walnuts ahead.

makes 6 servings

DRESSING

3 cups chopped rhubarb
 (about 6–8 medium-size
 stalks, cut into ½-inch pieces)
½ cup sugar
¼ cup rice vinegar
3 tablespoons chopped shallots
1 tablespoon Worcestershire
 sauce
½ teaspoon salt
¾ cup safflower oil

SALAD

1 cup shaved rhubarb
 (about 2–3 medium-size
 stalks, cut into very thin slices)
6–10 cups lettuce mix (Boston,
 baby spinach, baby romaine)
1 pint strawberries, hulled
 and sliced
1 bunch asparagus, trimmed,
 then grilled or steamed and
 cut into 2-inch pieces
4 ounces goat or feta cheese,
 crumbled
⅓ cup chopped Candied
 Walnuts (see right) or
 toasted walnuts

To make dressing, combine chopped rhubarb, sugar, and vinegar in a saucepan over medium-high heat; cook 6 minutes. Strain, reserving about ½ cup juices. Place juices, shallots, Worcestershire, and salt in the bowl of a food processor with a metal blade. Process, slowly adding oil until combined and emulsified.

To make salad, toss together shaved rhubarb, lettuce mix, strawberries, asparagus, and cheese in a large bowl. Add walnuts and just enough dressing to coat lightly. Refrigerate any leftover dressing up to 3 days.

Candied Walnuts: Combine **¼ cup water** and **½ cup brown sugar** in a medium-size saucepan over medium-high heat; bring to a boil, stirring until sugar dissolves. Stir in **1 cup walnut halves,** and continue to stir 5 minutes or until mixture thickens, dries, and coats walnuts. Pour onto parchment paper; allow walnuts to cool, and sprinkle with salt. Makes 1 cup.

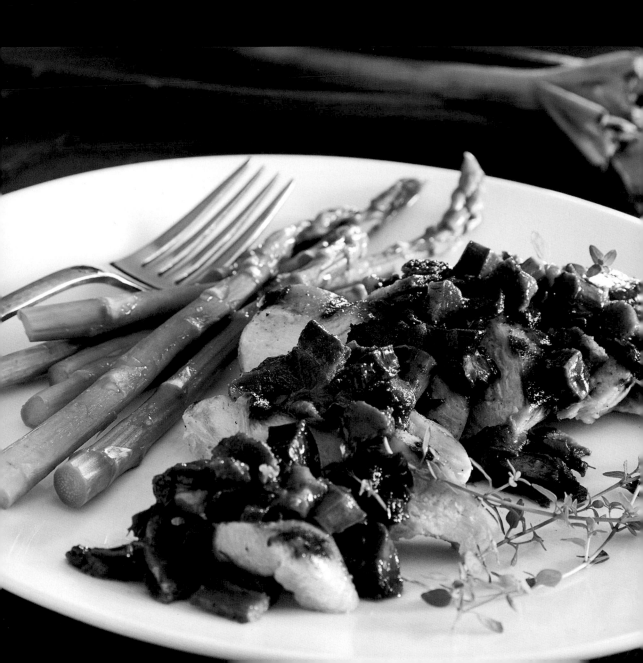

RB&O Sauce

This winning combination of rhubarb, bacon, and onion is delicious on grilled chicken breasts, pork tenderloin, and sausage. This recipe was adapted from the cookbook *Rhubarb Renaissance* by Kim Ode.

makes 1 cup

INGREDIENTS

2–4 slices thick-cut bacon,
 chopped into 1-inch pieces
1 cup finely chopped red onion
1 cup sliced rhubarb
 (about 2–3 medium-size
 stalks, cut into ¼-inch slices)
3 tablespoons maple syrup
1½ tablespoons red or white
 wine vinegar
Pinch allspice
Pinch dried thyme
 (or ¼ teaspoon fresh)

Cook bacon in a skillet over medium-high heat until crisp. Remove bacon to a paper towel, reserving drippings in skillet. Cook onion in drippings until lightly golden. Stir in rhubarb, maple syrup, vinegar, allspice, and thyme; cook over low heat, 5-7 minutes, until rhubarb is soft. Crumble in cooked bacon. Serve warm.

Rhubarb Ketchup

This ketchup pairs nicely with a spiced and herbed turkey burger.

makes 4 cups

INGREDIENTS

3 cups chopped rhubarb
 (about 6–8 medium-size
 stalks, cut into ½-inch pieces)
2 yellow onions, chopped
½ cup dark brown sugar
½ cup granulated sugar
½ cup apple cider vinegar
1 (14.5-ounce) can fire-roasted
 diced tomatoes
1½ teaspoons salt
½ teaspoon cinnamon
1 tablespoon pickling spice,
 tied into cheesecloth

Combine all ingredients in a heavy pot over medium-high heat. Bring to a boil, stirring frequently. Reduce heat and simmer, uncovered, for about 1 hour. Let cool, and remove pickling spice bag. Spoon rhubarb mixture into a blender, and puree until smooth. Transfer to a sterilized glass jar with lid; store in refrigerator.

Rhubarb Meat Pie

• •

I tested this recipe with Pepperidge Farm puff pastry sheets.

• •

makes 6 servings

INGREDIENTS
2 cups chopped rhubarb
 (about 3–5 medium-size
 stalks, cut into ½-inch pieces)
2 tablespoons light brown sugar
1 cup water
1 pound ground pork
1 yellow onion, chopped
¾ teaspoon celery seed
¾ teaspoon cloves
¾ teaspoon cinnamon
¾ teaspoon ginger
½ teaspoon nutmeg
3 bay leaves
¼ teaspoon salt
¼ teaspoon pepper
2 tablespoons sour cream
1 package puff pastry sheets,
 thawed
1 egg
1 tablespoon cold water

In a medium-size saucepan over medium-high heat, bring rhubarb, brown sugar, and 1 cup water to a boil and cook for 6 minutes; cool.

In a skillet, brown pork until meat crumbles and is no longer pink; drain meat and return to skillet. Add onion to skillet, and sauté until soft and slightly browned. Combine celery seed and next 7 ingredients in a small bowl; add to skillet. Stir in rhubarb mixture; cook until liquid is reduced. Stir in sour cream. Remove from heat, and cool slightly. Discard bay leaves.

Preheat oven to 400 degrees.

Transfer meat mixture to a ceramic pie plate. Drape puff pastry sheets over filling in pie plate. Whisk together egg and 1 tablespoon cold water in a small bowl; vent pastry, and brush with egg mixture. Bake for 40–50 minutes or until puff pastry is golden brown.

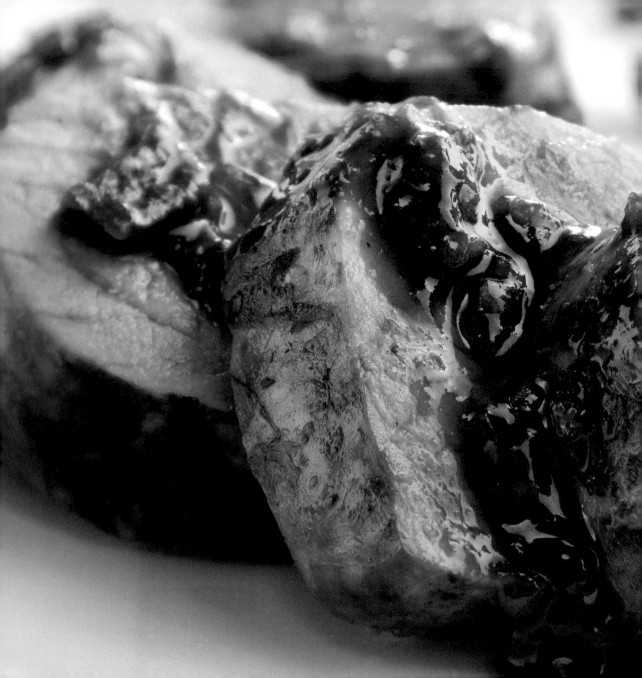

Pork Tenderloin with Rhubarb Sauce

INGREDIENTS

1 pound store-bought
 teriyaki-marinated
 pork tenderloins
2 tablespoons olive oil
1 cup chopped rhubarb
 (about 2–3 medium-size
 stalks, cut into ½-inch pieces)
¼ cup onion, minced
⅓ cup pomegranate juice
1 tablespoon apple cider vinegar
½ cup apricot preserves
½ teaspoon salt
2 turns freshly ground pepper

Preheat oven to 350 degrees.

Sear tenderloins in a skillet over medium-high heat until all sides are browned. Transfer pork to a roasting pan, and bake 10 minutes or until internal temperature reaches 145–150 degrees.

Meanwhile, add olive oil to skillet; sauté rhubarb and onion over medium heat until tender. Add juice and vinegar, scraping pan and incorporating bits of pork into rhubarb mixture. Add preserves, stirring to combine; season with salt and pepper. Serve sauce over pork loin.

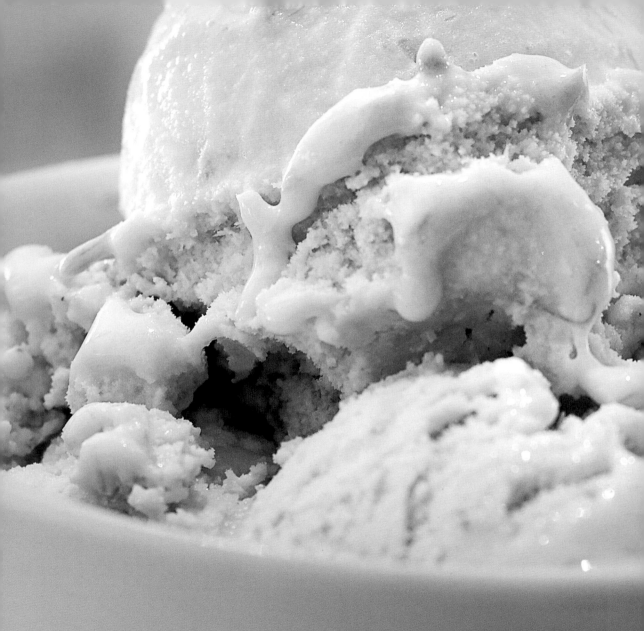

frozen treats

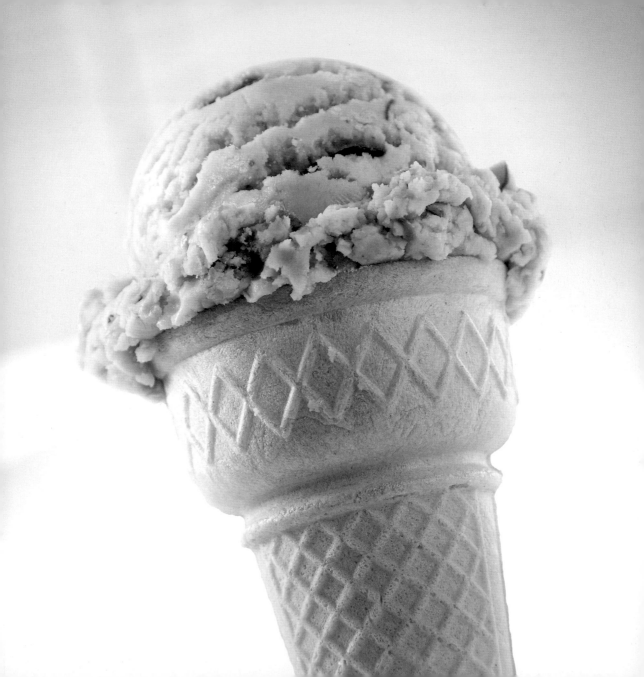

Rhubarb Ice Cream

• •

This recipe is adapted from one published in the *Chicago Tribune* on June 18, 2015.
The original recipe came from the grandmother of David Gott, of David's Famous Gourmet Frozen Custard.

• •

makes 6 servings

SAUCE
3 cups chopped rhubarb
 (about 6–8 medium-size
 stalks, cut into ½-inch pieces)
¾ cup sugar
½ cup water

CREAM
4 cups half-and-half
3 egg yolks
1 ¼ cups sugar
1 teaspoon vanilla extract
½ teaspoon salt

To make sauce, stir together rhubarb, ¾ cup sugar, and ½ cup water in a large saucepan over medium-high heat. Bring to a boil; simmer until rhubarb is soft (about 10 minutes). Transfer sauce mixture to an airtight container, and chill overnight.

To make cream, whisk together half-and-half, egg yolks, 1 ¼ cups sugar, vanilla, and salt in a large saucepan over medium-high heat. Whisk constantly until custard reaches 165 degrees on a candy thermometer. Whisk at 165 degrees for 30 seconds. Strain cream mixture into a clean bowl. Let cool. Cover and chill overnight.

Combine chilled rhubarb sauce and chilled cream in an ice-cream maker; churn according to manufacturer's instructions. Pack ice cream into plastic containers; press a sheet of plastic wrap on top, and freeze until firm (several hours).

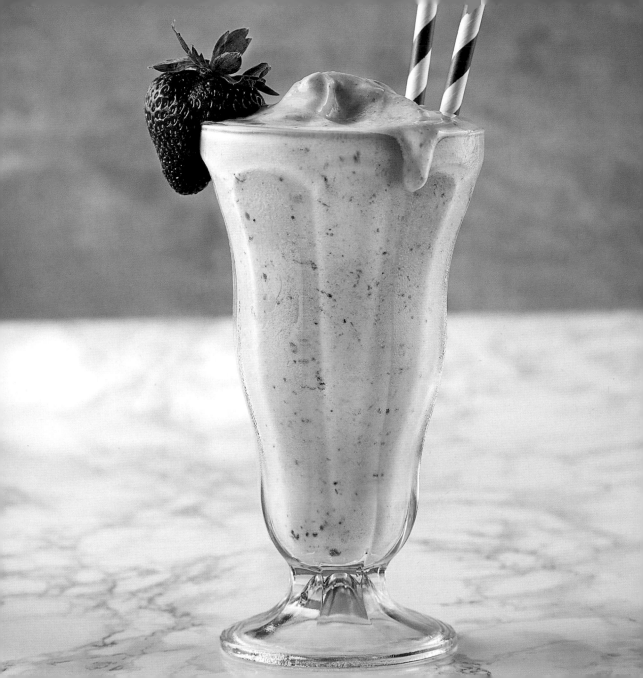

Strawberry-Rhubarb Milkshake

..

makes 3 (1-cup) servings

INGREDIENTS

½ cup frozen strawberries
⅓ cup whole milk
2 cups vanilla ice cream
½ cup Simple Rhubarb Sauce
(page 25)

Blend strawberries and milk in a blender until combined; add ice cream and Simple Rhubarb Sauce. Blend to desired consistency.

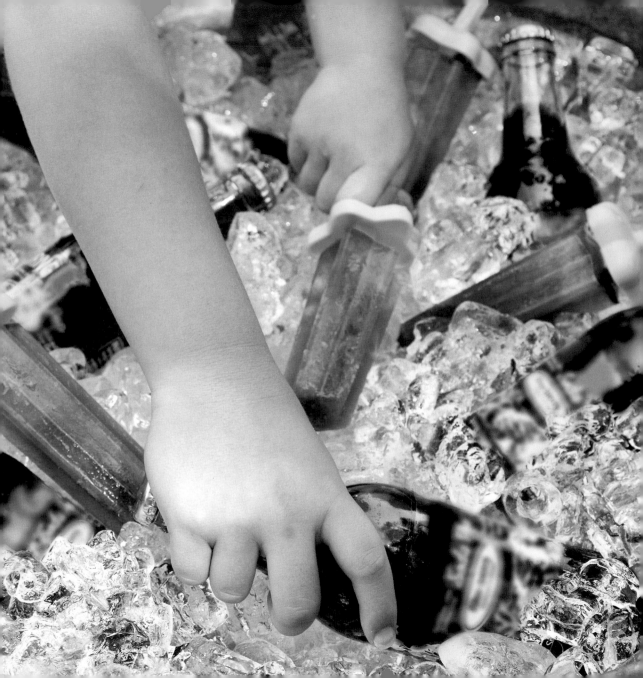

Rhubarb Ice Pops

Homemade ice pops are a nostalgic summertime treat. I remember balancing my ice-cube-size pop on a little toothpick, racing the heat to eat it all.

makes 2 cups (4 pops using a mold or 15 pops using an ice-cube tray)

INGREDIENTS
1½ cups chopped rhubarb
 (about 4 medium-size stalks,
 cut into ½-inch pieces)
¼ cup sugar
1–2 tablespoons honey
1½ cups strawberries, hulled
 and halved
2 teaspoons lemon juice
½ cup water

Cook rhubarb, sugar, and honey in a medium-size saucepan over medium heat, 7-10 minutes, until rhubarb is soft. Pour rhubarb mixture into the bowl of a food processor with a metal blade; add strawberries and lemon juice, and pulse twice to combine. Add ½ cup water until mixture is pourable but thick. Pour mixture into a large ice-cube tray or ice-pop molds. (If using an ice-cube tray, place a toothpick in each slot.) Freeze 4–6 hours.

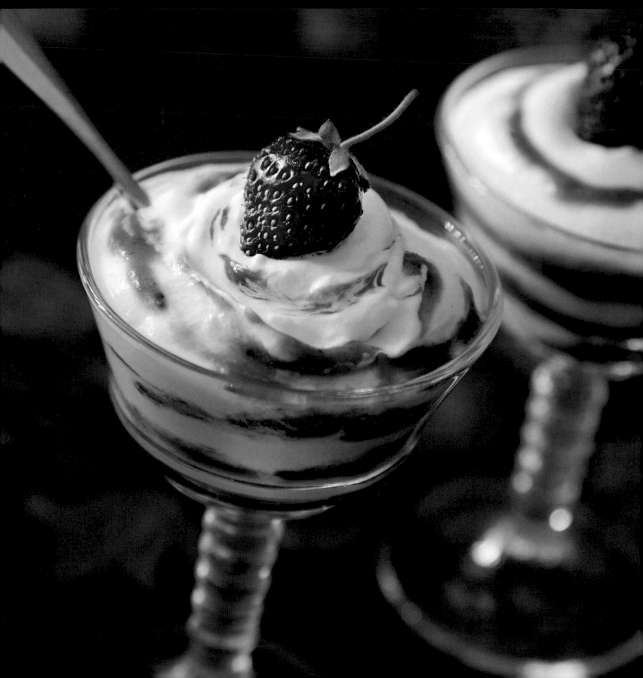

Rhubarb Fool

• •

There is no fool like a Rhubarb Fool. This classic English-Irish
dessert is made with whipped cream and cooked fruit.

• •

makes 6 servings

INGREDIENTS

3 cups chopped rhubarb
 (about 6–8 medium-size
 stalks, cut into ½-inch pieces)
2 cups strawberries, hulled,
 sliced, and divided
¼ cup honey or ⅓ cup sugar
¼ cup water
1 cup whipping cream
½ teaspoon vanilla extract
 or rosewater
1 tablespoon powdered sugar

GARNISH

6 small whole strawberries

Combine rhubarb, strawberries, honey, and ¼ cup water in
a medium-size saucepan over medium heat. Simmer, stirring
occasionally, 15 minutes or until rhubarb is the consistency
of applesauce. Pour rhubarb mixture into the bowl of a food
processor with a metal blade; pulse until smooth. Transfer to
a large covered bowl, and chill completely.

In a cold metal bowl, whip cream and vanilla until soft peaks
form. Sift in powdered sugar; whip until soft peaks form.
Fold whipped cream into chilled rhubarb mixture with a
rubber spatula. Gently swirl the cream and rhubarb mixture
together, until the mixture has streaks of rhubarb but is not
fully mixed. Spoon into 6 dessert dishes or wineglasses; chill
until ready to serve. Garnish each with a whole strawberry,
if desired.

Quick-and-Easy Rhubarb Fool: Strain **6 ounces Rhubarb
Jam** (page 115) into a large bowl; cover and chill. Stir
1 (12-ounce) container prepared whipped topping (such
as Cool Whip) into chilled jam just until streaks form. Spoon
mixture into 6 dessert dishes or wineglasses; chill until ready
to serve. Garnish each with a **whole strawberry**, if desired.
Makes 6 servings.

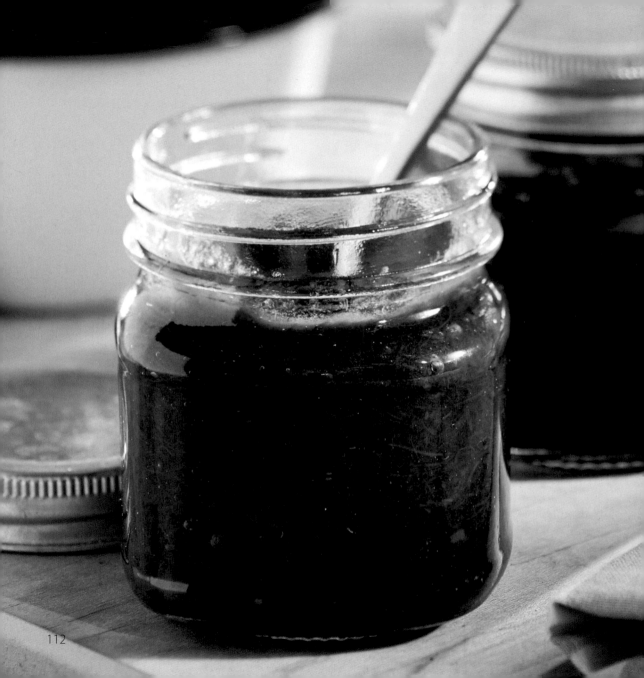

jams and jellies

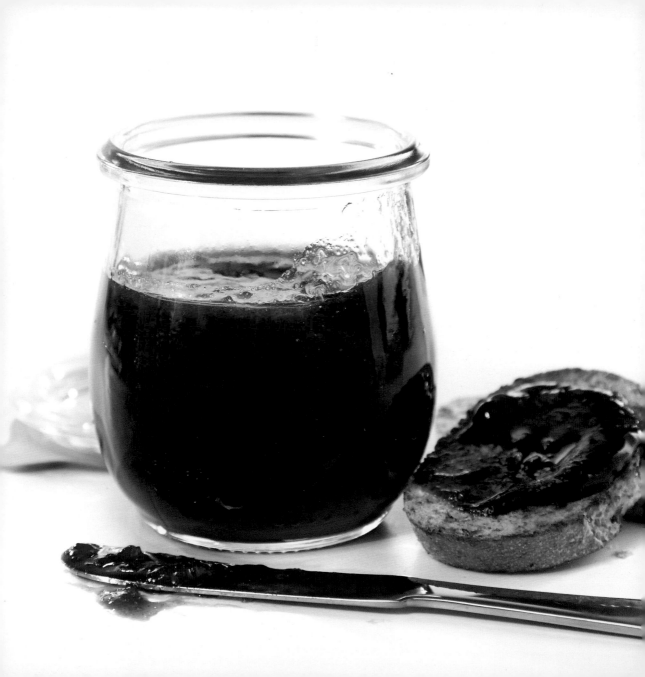

Rhubarb Jam

..

makes 4 (1-cup) jars

INGREDIENTS

2½ pounds rhubarb
 (about 15–20 medium-size
 stalks, cut into ½-inch pieces)
2 cups sugar
2 teaspoons grated orange zest
⅓ cup fresh orange juice
½ cup water

Combine rhubarb, sugar, zest, juice, and ½ cup water in a large pot over high heat; bring to a boil. Reduce heat to medium; cook 45 minutes, stirring occasionally, or until thickened. Ladle into hot sterilized jars, and seal with lids and rings. Cool. Store in refrigerator.

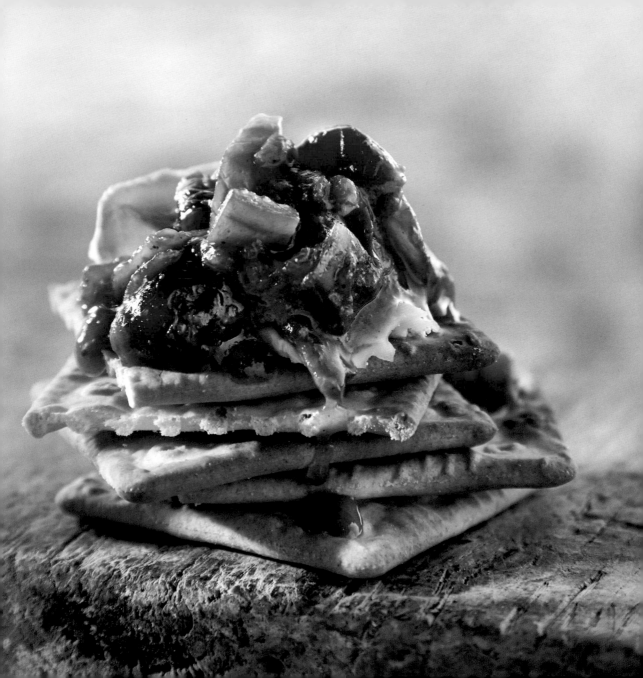

Rhubarb-Onion Chutney

makes 2 (1-cup) jars

INGREDIENTS

2 tablespoons olive oil

4 cups chopped rhubarb
(about 8–10 medium-size
stalks, cut into ½-inch pieces)

2 cups chopped red onion

1 tablespoon garlic

1 tablespoon ginger

1 jalapeño pepper, finely
chopped

1 cup dark brown sugar

½ cup dried tart cherries

½ cup white wine vinegar

1 teaspoon Garam Masala

½ teaspoon salt

¼ teaspoon pepper

Heat olive oil in a large, nonreactive, heavy saucepan over medium heat; sauté rhubarb, red onion, garlic, ginger, and jalapeño until softened. Stir in brown sugar, cherries, vinegar, Garam Masala, salt, and pepper; bring to a boil, reduce heat, and simmer, stirring occasionally, about 30 minutes. Cool. Ladle into sterilized glass jars with lids, and refrigerate.

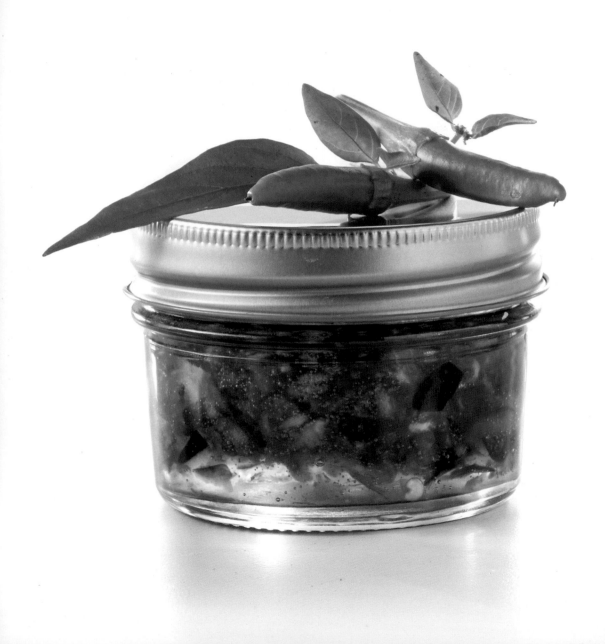

Rhubarb Hot Pepper Jelly

Pour this jelly over softened cream cheese and serve with crackers for a delicious go-to appetizer.

makes about 6 cups

INGREDIENTS

2 cups chopped rhubarb
(about 3–5 medium-size
stalks, cut into ½-inch pieces)

6 cups plus 2 tablespoons
sugar, divided

1 cup seeded and chopped red
bell pepper or banana pepper

½ cup seeded and chopped
jalapeño, serrano, or
Thai pepper

½ cup chopped red onion

1½ cups white vinegar

2 (3-ounce) pouches
liquid pectin

Bring rhubarb, 2 tablespoons sugar, and water to cover to a boil in a large pot over high heat. Reduce heat, and simmer, stirring occasionally, 30 minutes. Strain over a large bowl, reserving 1 cup rhubarb juice and discarding pulp. Return rhubarb juice to pot.

Place peppers and onion in the bowl of a food processor with a metal blade; pulse until pepper mixture is finely chopped.

Add pepper mixture, vinegar, and remaining 6 cups sugar to rhubarb juice in pot. Bring mixture to a full rolling boil, stirring constantly, 1 minute. Remove from heat, and stir in pectin, mixing well.

Using basic canning procedures, pour jelly mixture into hot jars, adjust lids, and process in boiling water bath for 10 minutes. Cool 30 minutes; invert and twist jars to distribute solids.

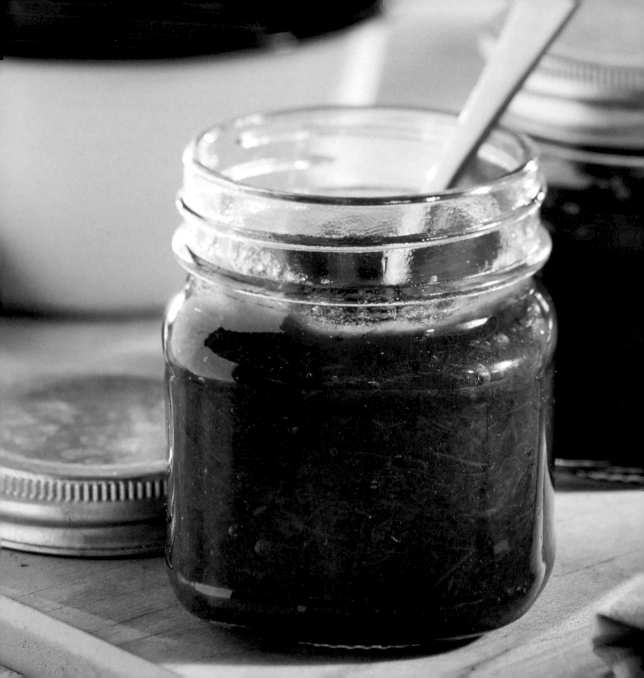

Small-Batch Strawberry-Rhubarb Jam

No canning is required for this great, 4-ingredient homemade jam.
Store in an airtight container in the refrigerator up to 3 weeks.

makes 2 cups

INGREDIENTS

3½ cups chopped rhubarb
 (about 8 medium-size stalks,
 cut into ½-inch pieces)
3 cups strawberries, hulled
 and halved
1½ cups sugar
2 tablespoons orange juice

Combine rhubarb, strawberries, sugar, and orange juice in a large saucepan over medium-high heat. Bring to a boil; reduce heat to medium-low, and cook 45–50 minutes. Fruit will cook down and thicken. Stir occasionally to prevent burning. Cool; cover and refrigerate.

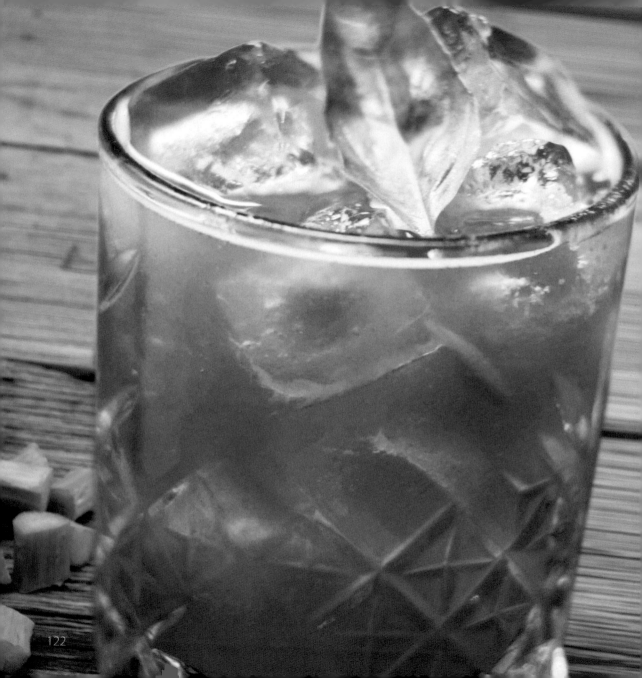

beverages

Rhubarb Simple Syrup

· ·

Use this simple syrup to make the following recipes.

· ·

makes 8 cups

INGREDIENTS
64 medium-size stalks rhubarb
¾ cup sugar
1 tablespoon lemon juice

Place rhubarb in juicer; juice according to manufacturer's instructions to yield 8 cups rhubarb juice. Combine juice, sugar, and lemon juice in a large pot over medium-high heat. Bring to a boil; reduce heat, and simmer, stirring occasionally, until sugar is dissolved. Cool. Using a funnel, pour syrup into sterilized glass jars with lids; refrigerate.

Rhubarb Slush Punch

∙∙

makes 30 cups

INGREDIENTS

8 cups Rhubarb Simple Syrup
 (page 124)
1 box strawberry gelatin mix
½ cup lemon juice
1 (46-ounce) can pineapple juice
6 cups orange juice
2 (2-liter) bottles 7UP, chilled

Combine Rhubarb Simple Syrup, gelatin mix, and juices in a large bowl. Divide mixture into 2 large freezer-proof containers, and freeze overnight. On the morning of your party, transfer containers to refrigerator; as mixture thaws, stir each to a slush consistency. Just before the party, place contents of 1 slush container in a punch bowl or drink dispenser, and add 1 bottle 7UP. Stir gently to combine. Refill punch bowl with contents of remaining 1 slush container and 1 bottle 7UP, as needed.

Rhubarb Bellinis

Bellinis are a favorite brunch, bridal, or baby shower choice. These drinks originated in Venice, where they're made with white peaches, Prosecco, and raspberry juice. A rhubarb Bellini will have a similar pink hue.

makes 10 servings

INGREDIENTS
1 cup Rhubarb Simple Syrup
 (page 124), chilled
1 bottle Prosecco or dry
 sparkling wine, chilled

GARNISH
 whole fresh raspberries

Add enough chilled Rhubarb Simple Syrup to each of 10 champagne flutes to fill each ¼ full. Slowly add chilled Prosecco to flutes, pouring at a tilt to preserve bubbles. Garnish, if desired, and serve immediately.

Rhubarb Daiquiris

This icy drink feels and tastes like a grown-up snow cone. Rhubarb's
unique flavor adds a fun twist to this classic beverage.

makes 4–6 servings

INGREDIENTS

1 cup Rhubarb Simple Syrup
 (page 124)
⅔ cup rum
2 tablespoons lemon juice
2 tablespoons lime juice
3 cups ice cubes

GARNISHES

 lemon and lime slices

In a blender, combine Rhubarb Simple Syrup, rum, juices,
and 3 cups ice cubes. Blend until smooth. Divide mixture
between 4–6 glasses; garnish, if desired.

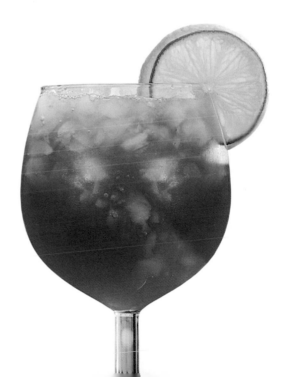

Rhubarb in the City

The television show *Sex in the City* made "The Cosmo" drink famous. I call this version Rhubarb in the City because it's a delicious, fun take on the vodka martini.

makes 2 servings

INGREDIENTS
4 ounces Rhubarb Simple Syrup
 (page 124)
2 ounces vodka
1 ounce Cointreau
2 teaspoons fresh lime juice

GARNISHES
 lime peel, small rhubarb stalks

Pour Rhubarb Simple Syrup, vodka, Cointreau, and lime juice into a cocktail shaker with ice. Shake well, strain, and pour into 2 martini glasses. Garnish, if desired.

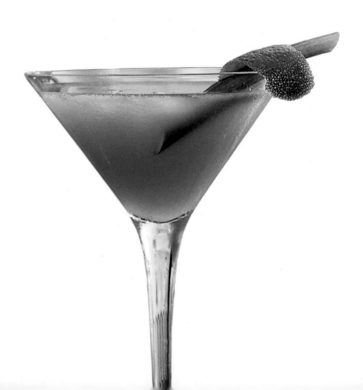

Rhubarb Pie Cocktails

Have your pie and drink it too! This cocktail was adapted from a recipe by *Altitude Spirits*.
To serve this drink without the cinnamon-sugar mixture on the rim, simply garnish with a fresh sprig of mint.

makes 2 servings

INGREDIENTS
¼ cup sugar
1 tablespoon cinnamon
2 tablespoons orange juice
4 ounces Rhubarb Simple Syrup
 (page 124)
2 ounces vodka
1 bottle (10 ounces) club
 soda, chilled

Mix together sugar and cinnamon in a shallow bowl. Dip rims of 2 highball-style glasses first in orange juice and then in cinnamon-sugar mixture; fill glasses with ice. Pour Rhubarb Simple Syrup and vodka into a cocktail shaker with ice; shake to combine. Pour into prepared glasses, and top off with club soda. Stir before serving.

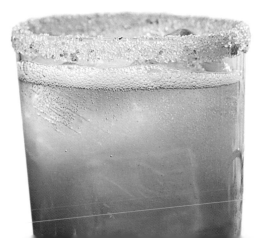

Index

A

Amaretto, 73
Americanized Devonshire Cream, 37
apple pie filling, 63

B

bacon, 95
bars
 Rhubarb Dream Bars, 86–87
 Rhubarb Oatmeal Cookie Bars, 84–85
Best Double Piecrust, 48–49
beverage recipes
 Rhubarb Bellinis, 126
 Rhubarb Daiquiris, 127
 Rhubarb in the City, 128
 Rhubarb Pie Cocktails, 129
 Rhubarb Simple Syrup, 124
 Rhubarb Slush Punch, 125
blueberries
 Fourth of July Blubarb Pie, 56–57
 Rhubarb-Blueberry Breakfast Sauce, 44–45
bowel complaint remedy, 12
breakfast rhubarb recipes, 30–45
butter, creaming with sugar, 17

C

cakes
 Rhubarb Cheesecake, 80–81
 Rhubarb Cupcakes with Strawberry Frosting,
 74–75
 Rhubarb Upside-down Cake, 78–79
 Rhubarb-Strawberry Shortcake, 76–77
candied walnuts, 93
cheesecake, rhubarb, 80–81
cherries, Rhubarb-Onion Chutney, 116–117
chutney, rhubarb onion, 116–117
cobbler, rhubarb, 70–71
cocktails, rhubarb pie, 129
coffee cake, rhubarb, 38–39
cookies
 Rhubarb Jam Pinwheel Cookies, 82–83
 Rhubarb Oatmeal Cookie Bars, 84–85
cooking with rhubarb, tips for, 16–17
cookware, 16
Cuisinart food processor, 16
custard cake, rhubarb, 28–29

D

dessert recipes with rhubarb, 68–87

E

egg washes, 17

F

Fourth of July Blubarb Pie, 56–57
Franklin, Benjamin, 12
freezing rhubarb, 16
frosting, strawberry, 75
frozen treats, 102–111

G

galette, rhubarb, 58–59
gluten-free recipes
 Pavlova with Rhubarb, Strawberries,
 and Fresh Cream, 72–73

Rhubarb-Blueberry Breakfast Sauce, 44–45
Simple Rhubarb Sauce, 24–25
Gott, David, 105
Grandma's Rhubarb Custard Pie, 50–51
growing rhubarb, 14

H
hand-pie pops, rhubarb, 62–63
harvesting rhubarb, 14
Hawkins, Donna, 49
hot pepper jelly, rhubarb, 118–119

I
ice cream
 rhubarb, 104–105
 vanilla, 23, 25
ice pops, rhubarb, 108–109

J
jams and jellies
 Rhubarb Hot Pepper Jelly, 118–119
 Rhubarb Jam, 114–115
 Rhubarb-Onion Chutney, 116–117
 Small-Batch Strawberry-Rhubarb Jam, 120–121

K
ketchup, rhubarb, 96–97
Kozlak, Corrine, 136

M
Mandel, Abby, 27
meat pie, rhubarb, 98–99
milkshake, strawberry-rhubarb, 106–107
Mini Strawberry-Rhubarb Tarts, 66–67
muffins, rhubarb-bran breakfast, 34–35

O
oatmeal, Rhubarb Oatmeal Cookie Bars, 84–85
onion
 chutney, rhubarb, 116–117
 RB&O Sauce, 94–95
orange juice, 25, 27
Overnight Oatmeal Cake with Rhubarb Sauce, 32–33
oxalic acid, 10

P
parfait, rhubarb, 42–43
Pavlova with Rhubarb, Strawberries,
 and Fresh Cream (gluten-free), 72–73
peaches, Peach-Rhubarb Pie, 60–61
Peach-Rhubarb Pie, 60–61
peppers, Rhubarb Hot Pepper Jelly, 118–119
pie plates, 16
piecrusts
 Best Double Piecrust, 48–49
 making fluted edges, 17
 making lattice, 18–19
 store-bought, 11
 tips for making lattice, 18–19
pies
 Best Double Piecrust, 48–49
 Fourth of July Blubarb Pie, 56–57
 Grandma's Rhubarb Custard Pie, 50–51
 Mini Strawberry-Rhubarb Tarts, 66–67
 Peach-Rhubarb Pie, 60–61
 recipes for, 46–67
 Rhubarb Galette, 58–59
 Rhubarb Hand-Pie Pops, 62–63
 Rhubarb Meat Pie, 98–99

(pies, continued)
 Rhubarb Streusel Pie, 54–55
 Rhubarb Tarte Tatin, 64–65
 Straight-up Perfect Rhubarb Pie, 22–23
 Strawberry-Rhubarb Pie, 52–53
Pillsbury Moist Supreme Yellow Premium
 Cake Mix, 29
pork, ground, 99
Pork Tenderloin with Rhubarb Sauce, 100–101
punch, rhubarb slush, 125

R

raspberries, Rhubarb Galette, 58–59
RB&O Sauce, 94–95
rhubarb
 See also specific recipes
 best basic recipes, 20–29
 beverage recipes, 122–129
 bowel complaint remedy, 12
 breakfast recipes, 30–45
 dessert recipes, 68–87
 frozen treats, 102–111
 growing, 14
 history of, 12–13
 introduction to, 10–11
 medical uses of, 10, 12
 pie recipes, 46–67
 sauce, 24–25, 33
 savory main and side dishes, sauces, 88–101
 tips for cooking with, 16–17
Rhubarb Bellinis, 126
Rhubarb Cheesecake, 80–81
Rhubarb Cobbler, 70–71

Rhubarb Coffee Cake, 38–39
Rhubarb Crisp, 26–27
Rhubarb Cupcakes with Strawberry Frosting, 74–75
Rhubarb Custard Cake to Take, 28–29
Rhubarb Daiquiris, 127
Rhubarb Dream Bars, 86–87
Rhubarb Fool, 110–111
Rhubarb Galette, 58–59
Rhubarb Hand-Pie Pops, 62–63
Rhubarb Hot Pepper Jelly, 118–119
Rhubarb Ice Cream, 104–105
Rhubarb Ice Pops, 108–109
Rhubarb in the City, 128
Rhubarb Jam, 114–115
Rhubarb Jam Pinwheel Cookies, 82–83
Rhubarb Ketchup, 96–97
Rhubarb Meat Pie, 98–99
Rhubarb Oatmeal Cookie Bars, 84–85
Rhubarb-Onion Chutney, 116–117
Rhubarb Parfait, 42–43
Rhubarb Party Salad, 92–93
Rhubarb Pie Cocktails, 129
Rhubarb Salsa, 90–91
Rhubarb Scones, 36–37
Rhubarb Simple Syrup, 124, 125, 126, 127, 128, 129
Rhubarb Slush Punch, 125
Rhubarb Streusel Bread, 40–41
Rhubarb Streusel Pie, 54–55
Rhubarb Tarte Tatin, 64–65
Rhubarb Upside-down Cake, 78–79
Rhubarb-Blueberry Breakfast Sauce (gluten-free),
 44–45
Rhubarb-Bran Breakfast Muffins, 34–35

Rhubarb-Strawberry Shortcake, 76–77

S
salad, rhubarb party, 92–93
salsa, rhubarb, 90–91
sauces
 Pork Tenderloin with Rhubarb Sauce, 100–101
 RB&O Sauce, 94–95
 rhubarb, 33
 Simple Rhubarb Sauce, 24–25
savory main and side dishes, sauces, 88–101
scones, rhubarb, 36–37
shortcake, rhubarb-strawberry, 76–77
Simple Rhubarb Sauce (gluten-free), 24–25
Small-Batch Strawberry-Rhubarb Jam, 120–121
Straight-up Perfect Rhubarb Pie, 22–23
strawberries
 Mini Strawberry-Rhubarb Tarts, 66–67
 Pavlova with Rhubarb, Strawberries, and Fresh
 Cream, 72–73
 recipes with, 10
 Rhubarb Crisp, 26–27
 Rhubarb Cupcakes with Strawberry Frosting,
 74–75
 Rhubarb Fool, 110–111
 Rhubarb Ice Pops, 108–109
 Rhubarb Jam Pinwheel Cookies, 82–83
 Rhubarb Parfait, 42–43
 Rhubarb-Strawberry Shortcake, 76–77
 Small-Batch Strawberry-Rhubarb Jam, 37,
 120–121
Strawberry-Rhubarb Milkshake, 106–107
Strawberry-Rhubarb Pie, 52–53
Strawberry-Rhubarb Milkshake, 106–107

Strawberry-Rhubarb Pie, 52–53
streusel, 35, 41, 54–55
sugar, creaming with butter, 17
syrup, rhubarb simple, 124, 125, 126, 127, 128, 129

T
tapioca, 17, 23, 27, 53, 61
tarte tatin, rhubarb, 64–65
tarts, mini strawberry-rhubarb, 66–67

V
vanilla ice cream, 23, 25

W
walnuts, candied, 93
whipping cream, 73, 77, 111